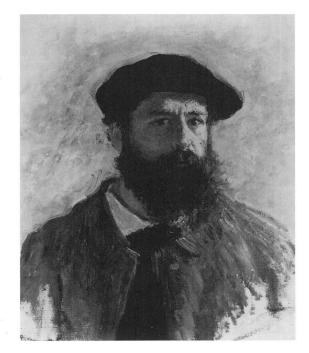

Claude Monet

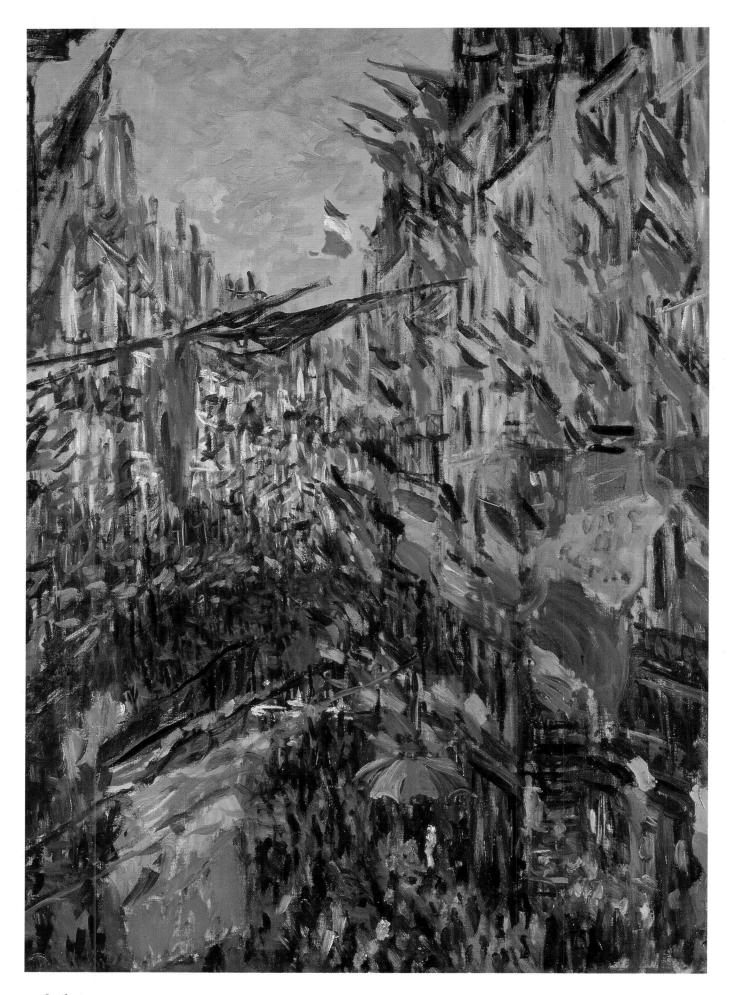

Christoph Heinrich

CLAUDE MONET 1840–1926

FRONT COVER: **Water Lilies** (detail), 1914 Oil on canvas, 200 x 200 cm Wildenstein 1800 Tokyo, The National Museum of Western Art, Matsukata Collection

> ILLUSTRATION PAGE 1: Self-Portrait in a Beret, 1886 Oil on canvas, 56 x 46 cm Wildenstein 1078 Private collection

ILLUSTRATION PAGE 2: Festivities in the Rue Saint-Denis, 30 June 1878, 1878 Oil on canvas, 76 x 52 cm Wildenstein 470 Rouen, Musée des Beaux-Arts

> BACK COVER: Claude Monet, 1901 Photograph by Gaspar Félix Nadar

759.4 OCLC 8/6/03 Hei

Published by Thunder Bay Press 5880 Oberlin Drive, Suite 400 San Diego, CA 92121-9653 1-800-284-3580 Library of Congress Cataloging in Publication Data available on request.

This book was printed on 100 % chlorine-free bleached paper in accordance with the TCF standard.

© 1997 Benedikt Taschen Verlag GmbH Hohenzollernring 53, D-50672 Köln English translation: Michael Hulse, Cologne

Printed in Germany ISBN 1-57145-128-5

97 98 99 00 1 2 3 4

19.

Contents

6 Making the Salon

16 Monet Finds his Subject Matter

24 The World as a Month of Sundays

> 34 The Bridges at Argenteuil

> > 44

Winter at Vétheuil

54 Concentration and Repetition:

Working in Series

62

Different Countries and Different Light

70 The Garden at Giverny

92 Claude Monet 1840–1926: a Chronology

> 94 List of Plates

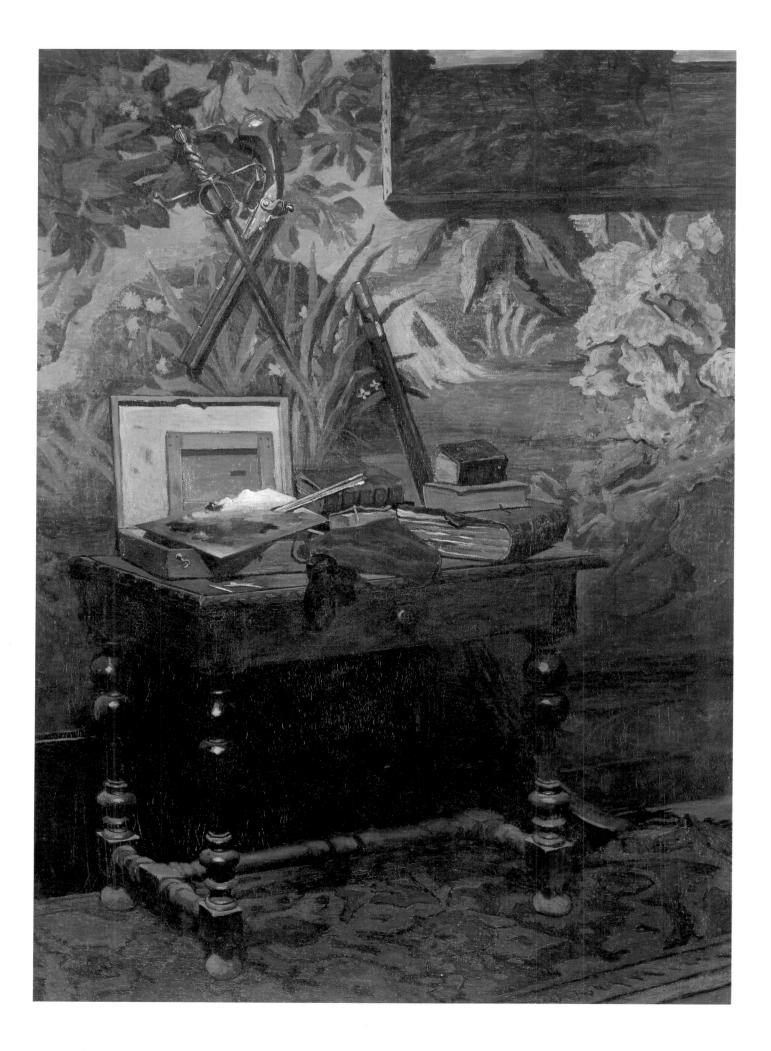

Making the Salon

With hindsight we can see a still life Claude Monet painted at the outset of his long and prolific career (p. 6) as a programmatic statement. A painter's brushes, paintbox and palette, as well as books, are on a table, with weapons against and above it, and as a backdrop wallpaper featuring vegetation, water and exotic birds, in the manner of an old tapestry. The youthful artist is meticulous in his attempt to convey the moist gleam of the paint, the matt velvet of the cap, the dry book binding, and the metal on the guns and dagger. It is the work of an artist out to show what he can do. And it is a picture unusual in its contrasts – between the somewhat drab utility objects and the opulent tropical river scene in the background, between the earthy tonalities of the interior and the cool moist verdure of the lush scene behind.

What is also unusual in this early Monet is its captivating brightness. On the palette, alongside green, red and black, there is a mass of moist paint: white lead. That white lead is the source and crux of the painting's light. Its fresh whiteness fills the entire space, shedding its light upon a painter's entire life. And that light *is* the manifesto.

Claude Monet was *the* incomparable painter of bright daylight – the painter of the sky, the snow, clouds reflected in water, the first painter ever to paint pictures almost entirely monochrome white. Till his old age, till his majestic late paintings of waterlilies, Monet continued to mix this white into his pure colours, thus banishing the muted shades of somnolent interiors (still visible in this early work) from the art. Monet was the painter of light.

At a time when solo exhibitions were not yet customary, the biannual Paris Salon constituted the major showcase and market for French painters. For six weeks, the most recent work of establishment artists, diligent pupils, ambitious imitators, and every so often a painter of genuine talent was on display to a public that stinted neither its praise nor its criticism. In the 18th century it had been possible to presuppose a certain expertise among aristocratic patrons of art; a century later, the Salon was a Sunday pastime open to all. In the Palais de l'Industrie (where the Salon had been held since the 1855 World Fair) the middle classes, now enthroned as the socially dominant class, strolled by with hat and cane or in rustling gowns, holding relaxed conversation and eagerly aped by all who aspired to similar prosperity. The pleasure principle ruled. The critics would devote pages to the Salon in popular journals such as the Journal du Rire or Charivari, and their reviews served that principle, supplying euphoric paeans or malicious caricatures to create and shape public taste. Even before they had seen the paintings in the original, people would be going into raptures or fits of laughter. The oppor-

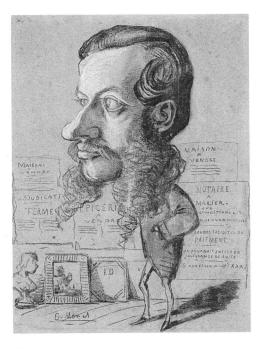

The Notary Léon Marchon, c. 1855/56 In his home town of Le Havre, Monet acquired the reputation of an enfant terrible and gifted cartoonist with his caricatures of local public figures.

Studio Still Life, 1861

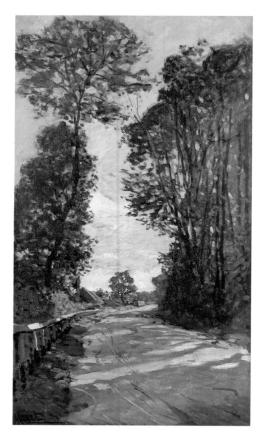

The Road to Saint-Siméon's Farm near Honfleur, 1864

Eugène Boudin: *The Beach at Trouville*, 1864 Boudin introduced Monet to *plein-air* technique and confirmed his resolve to be a painter. tunity to exhibit at the Salon, and the verdict of the critics, were decisive in gaining an artist recognition – or leaving him in obscurity, to drain his family's purses further and perhaps to end in penury.

It is true that the Salon was a thing of sensationalism and attention-getting. The painters ransacked mythology and folk tales in quest of murders, triumphant heroes, and a pretty excuse to paint a little naked flesh. Nevertheless, it would be wrong to imagine it the exclusive reserve of bad taste. At the Salon, after all, following a lengthy struggle, Eugène Delacroix and Gustave Courbet, Jean-François Millet, Jean-Baptiste-Camille Corot and Edouard Manet exhibited their paintings. At the Salon they attracted attention, scoring modest successes or sparking off scandals. A good Salon year would feature the entire spectrum of art, from skilful old-master styles to the Barbizon School's unconventional approach to the picturesque. To a young artist, much of the work on display could come as a revelation.

One of the youthful artists who walked the Salon wide-eyed in wonder was Claude Oscar Monet. Born in Paris in 1840, he grew up in modest lower-middle-class circumstances. His father's grocery was failing and the family moved to the harbour town of Le Havre; there, Monet senior entered his brother-in-law Jacques Lecadre's wholesale business. Oscar (as he was initially called) was then six years old. He was to spend his boyhood on the rough coast of northern France, with its bright light, restless sea, and everchanging wind and weather, but with its fashionable resorts of Deauville, Trouville and Honfleur too, magnets for city folk. The family summered at Aunt Sophie's pretty country house at Sainte-Adresse, while in winter they remained at Le Havre. Monet roamed the beach, dunes and cliffs above the sea all day long, and often played truant from school to do so. At the age of fifteen he achieved a certain notoriety with his barbed pencil caricatures of teachers and other persons of public note in Le Havre (p.7). Blessed with his family's business sense, Monet sold the drawings and managed to up his pocket money not insignificantly.

But of greater importance than such five-finger exercises (which were often closely based on magazine illustrations) was the young Monet's friendship with the painter Eugène Boudin. Boudin specialized in airy coastal pastels (p.8). He would take Monet along when he painted at beach resorts, and introduced the youth to the new technique of *plein-airisme*. "If I became a

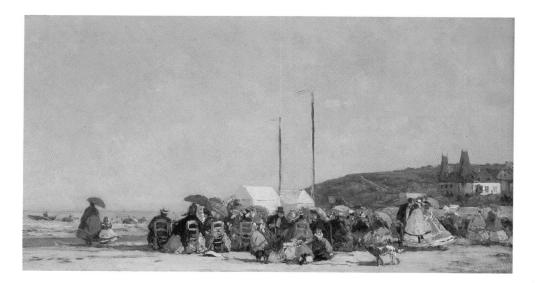

painter," Monet recalled in 1900, "it was thanks to Boudin. He was a man of infinite kindness and took it upon himself to teach me. Gradually my eyes were opened, I really understood Nature, and at the same time I began to love it."

Monet left school shortly before the leaving exams, to become a painter. His mother, who might have supported him in his wish, had died in 1857; his father, who saw the lad as his own successor in the now prosperous family business, was unenthusiastic and refused him an allowance, but let him go his way, doubtless hoping the fad would blow over. Taking his earnings from caricatures, Monet headed for Paris and enrolled at the Académie Suisse, a small private art school. He visited the Salon, and wrote to Eugène Boudin (on 20 February 1860): "I am surrounded by a small group of land-scape artists here, who would be very happy to meet you. They are real painters."

While convalescing at Le Havre following a brief spell of military service in Algeria, from which he returned with a bout of typhoid fever, Monet met the Dutch painter Johan Barthold Jongkind, whose landscapes the Frenchman had already admired at the Salon. Jongkind painted sunny landscapes, his brushwork light and relaxed, and was an immediate precursor of Impressionism. From their first meeting, he became Monet's "true master", as Monet recalled in 1900: "It was he who completed the education of my eye." In the opinion of the Monet-Lecadre family, though, this crazy Dutchman with a penchant for the bottle was unsuitable company for young Claude – so in 1862 he was sent back to Paris, on condition that if he really insisted on becoming a painter he take the accepted course, via the Ecole des Beaux-Arts.

Cape La Hève at Ebb Tide, 1865

In his early paintings, Monet captured the sea and sky of his home parts in Normandy, watching the sun as it broke through clouds or lit a lane near Honfleur. His whole life long he remained true to the landscape of northern France.

Avenue at Chailly, 1865

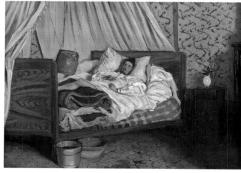

Monet, however, had no interest in the prevailing tone of the academy. He joined Charles Gleyre's independent tuition studio. Gleyre's own style was idealistic, and well in line with Salon taste, but he granted his students their freedom and encouraged them to evolve an independent style of their own. The encouragement and instruction of this good-natured teacher, who seems to have been led a merry dance by his pupils, Monet largely rejected. For him, classes provided an opportunity to study nudes, and above all a way of meeting like-minded contemporaries.

At Gleyre's, Monet met three young artists named Frédéric Bazille, Alfred Sisley and Auguste Renoir; he had already made the acquaintance of Camille Pissarro before military service. These four were to be the core of the Impressionist movement. Monet himself was anything but bohemian, and indeed behaved in a distinctly middle-class way. Renoir was later to tell his son that the other students called Monet "the Dandy": "He didn't have a sou, but he wore shirts with lace cuffs. [...] To one student who was making up to him, a pretty but vulgar girl, he replied: I'm sorry, but I only sleep with duchesses or maids. Anything in between I find revolting. The ideal would be a duchess's maid."

Still, the actual circumstances in which the two artists lived and worked (at times together) could fairly be called bohemian. They earned paltry sums from portrait work and occasional commissions, and Monet even tried to make his way as a cartoonist; but the money went on rent, fuel, and the girls who sat as models. They ate meagrely, accepted payment in groceries from one man who commissioned work, and at one point lived for a month on a sack of beans – which could be cooked on the stove, since it had to be lit anyway if a model was to pose in the nude. Once the beans ran out, they changed to lentils. In later years, when his son asked if a diet of pulses was not rather indigestible, Renoir merely laughed: "I was never so happy in my entire life. And Monet did contrive an invitation to dinner from time to time, whereupon we'd stuff ourselves with turkey washed down with Chambertin."

<u>Frédéric Bazille:</u> *Improvised Treatment*, 1865 During the Paris years, Monet and his newfound friends Renoir, Sisley and Bazille frequently painted in the Forest of Fontainebleau. On one of their excursions Monet was

injured, and was nursed by Bazille.

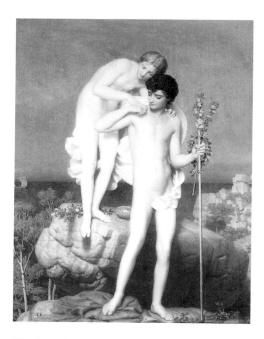

Charles Gleyre:

Daphnis and Chloe Returning from the Mountains, 1862

Monet's teacher Gleyre was a meticulous craftsman who served contemporary preferences and tastes. His pictures suited the Academy's norms; he was not a great artist himself, but the roots of Impressionism lay in his studio.

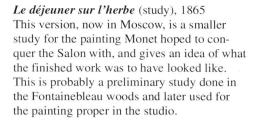

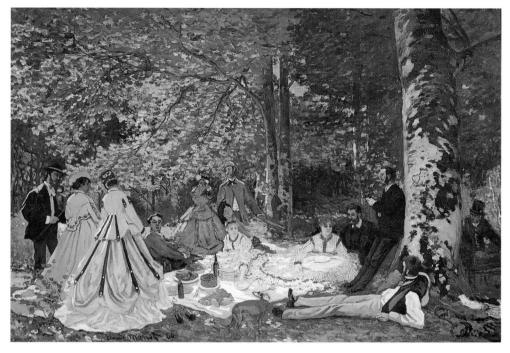

Despite this imbalanced diet and his resolute refusal to put himself in the hands of an academic teacher, Monet was presently scoring his first Salon successes. "A new name must be mentioned," a critic wrote in the *Gazette des Beaux-Arts* in July, 1865. "Monsieur Monet, the painter of *Cape La Hève at Ebb Tide* (p.9) and *The Mouth of the Seine at Honfleur*, was hitherto unknown. These works constitute his debut – and they still lack that finesse which comes with long study. But his feel for colour harmonies in an interplay of related tones, and indeed his sense of colour values as a whole, as well as the notable overall character, his daring way of seeing and of enforcing our attention – all these are advantages which Monsieur Monet already possesses in a high degree. Henceforth we shall be following the work of this upright painter of the sea with great interest."

The *Gazette* critic of the 1865 Salon was happy to hail a new young artist from whom much could be expected in future; and indeed it was to the critic's credit that, amid the countless paintings hung as many as five rows high, he was alert to the qualities of Monet's two landscapes, so reticent in colour tonalities, so simple in their choice of everyday subject matter. But of course it was also to the credit of the youthful painter, making a quiet Salon debut in marked contrast to the noise of some arrivals.

Perhaps it was the work of the Barbizon School that opened this critic's eyes to immediacy in the handling of the natural scene. In his early years, Monet was in fact very close to that particular line of realist art. The Barbizon painters worked on the fringes of the Forest of Fontainebleau and included Corot, Charles François Daubigny and Constant Troyon, among others. They took their subjects from ordinary life, spurning the lofty historical and anecdotal themes then so popular with the public. Their work was notable for its careful scrutiny of Nature – though in point of fact their paintings were generally done in the studio. Monet too painted in the Forest of Fontainebleau at times (p. 10), meeting the Barbizon artists; but his ambition went beyond painting landscapes in the manner of the Barbizon masters. Fig-

Even as an old man, Monet kept the centre portion of *Le déjeuner sur l'herbe* in his studio and liked to tell visitors (here, the Duc de Trévise) how it came to remain unfinished.

Edouard Manet: *Le déjeuner sur l'herbe*, 1863

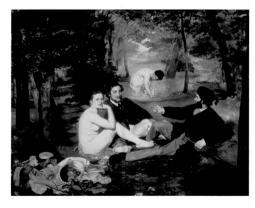

ure painting, preferably in large formats, struck Monet as a guarantee of success: if works were not to be assigned remote, unworthy positions under the ceiling by the hanging commission, where Salon-goers would need binoculars to see them, they had to make an unmissable impact, and painters were therefore turning to immense outsize formats – *grandes machines*, as the Parisians dubbed them. And Monet, young rebel though he was, unconventional though he was in his draughtsmanship and use of colour, was definitely out for success in the official arena of the Salon.

A few years before, Manet – whose work was controversial in the extreme, and repeatedly turned down by the Salon – had caused a sensation with *Déjeuner sur l'herbe* (p. 12). This scene, showing two city gentlemen in a clearing, lunching on bread, wine and fruit and accompanied by a naked lady, while in the background a second woman washes her feet, was a *succès de scandale*. The self-same public that lauded the nude Venus of Salon painter Alexandre Cabanel, a work that could scarcely be outdone in its saccharine lasciviousness, could barely be restrained from spitting upon Manet's *Déjeuner*. Their outrage was presumably prompted by the fact that Manet did not hide behind a mythological fig-leaf; but the ease of his painting style also struck contemporaries as coarse.

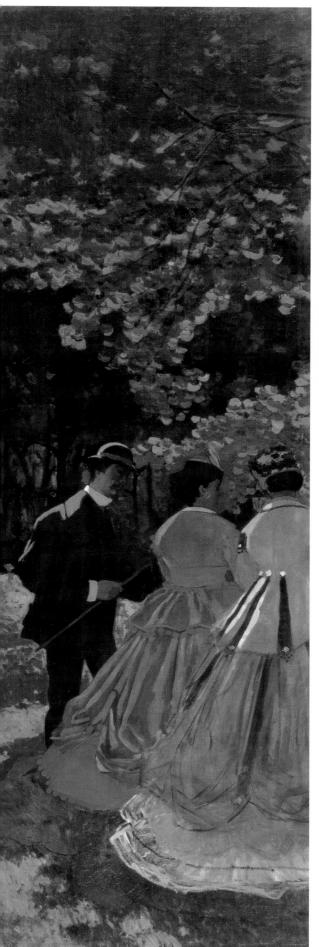

Le déjeuner sur l'herbe (left and centre sections), 1865

Several months behind on the rent, Monet gave the painting to his landlord in lieu. Years later, when he went to reclaim it, it was moulded over and badly damaged by damp. Only two sections of the huge work could be saved.

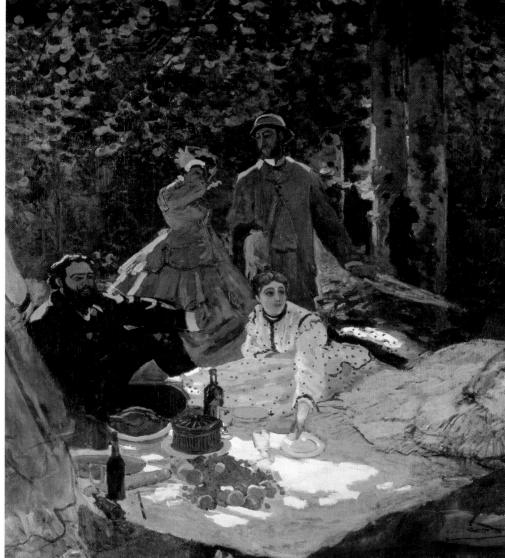

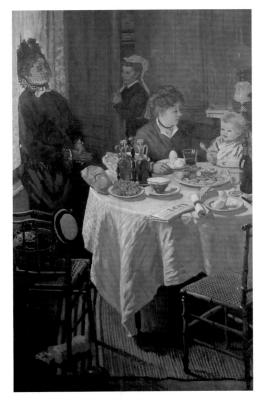

Luncheon,1868

A middle-class idyll, and for Monet, still poor, a dream of things to come. This painting, his last under the influence of Manet, presents the brunch-like meal commonly taken in the late morning in France, where salad and wine may be offered along with the morning egg and paper.

Camille, or, Lady in a Green Dress, 1866

Monet, for his part, was enthusiastic about Manet's skills. He had seen works by the other artist for the first time in 1863, and promptly began to lighten his palette. He himself then tried to outdo Manet in a *tour de force* of his own, a *Déjeuner* measuring no less than 4.20 by 6.50 metres and including a full dozen lifesize figures gathered in a birch forest to luncheon on stuffed fowl, pie and wine (pp. 11–13).

Manet's painting was a studio work, and used every trick of the trade; but Monet painted in the open, questing for immediacy of effect. Manet shocked his public by presenting a naked woman (gazing challengingly into our eyes) without any allegorical pretext, beside gentlemen dressed in the clothes of the day; Monet, in his painting, turned the occasion into a Paris society picnic. It was as if he had taken the criticism of his elder fellow-artist's work to heart and was on his best behaviour to curry favour with the Salon.

He painted it in 1865. That summer, together with his nineteen-year-old lover Camille Doncieux and his friend Bazille (with whom he was sharing a studio), he went out to the Forest of Fontainebleau, and there the two of them patiently sat, stood and lay – modelling for all of the figures in the painting. That autumn, in the Paris studio, Monet set about transposing the study to large format. He worked like one possessed that winter, only to realise – shortly before the Salon opened – that he would not have it finished. He put it aside, and in just four days, as legend insists, painted a full-length portrait of Camille: *Lady in a Green Dress* (p. 15).

If the landscapes Monet exhibited at the previous Salon had attracted generous comment, the portrait of Camille scored a huge success. Critics never tired of praising his handling of the silken fabric of the dress, comparing it with the old masters and even with the famous materials of the Venetian artist, Veronese. "Just consider that dress," wrote Emile Zola. "It is both supple and firm. Softly it drags, it is alive, it tells us quite clearly something about this woman. It is not a doll's dress, the muslim dreams are wrapped in: this is fine, real silk, really being worn." Critics admired the lifelike figure, turning to go. The fleeting quality of the moment seemed to have been captured both in the pose and in the very painting. Zola was very interested in the realist painters, and exulted: "Truly – this is a temperament, this is a real man in this pack of eunuchs!"

In his *Déjeuner*, Monet had hoped to outdo Manet; but *Camille*, or, *Lady in a Green Dress* brought him acclaim, and he was named in the same breath as Manet. "Monet or Manet?" demanded the critic of *La Lune*. "Monet. But we have Manet to thank for Monet. Bravo, Monet! Thank you, Manet!" Success put wings on Monet's motivation, and he pressed on with figure painting. He did not abandon his plan to do a major figure painting, but now he turned to a somewhat smaller picture showing four women in the open, and determined to paint it completely out of doors.

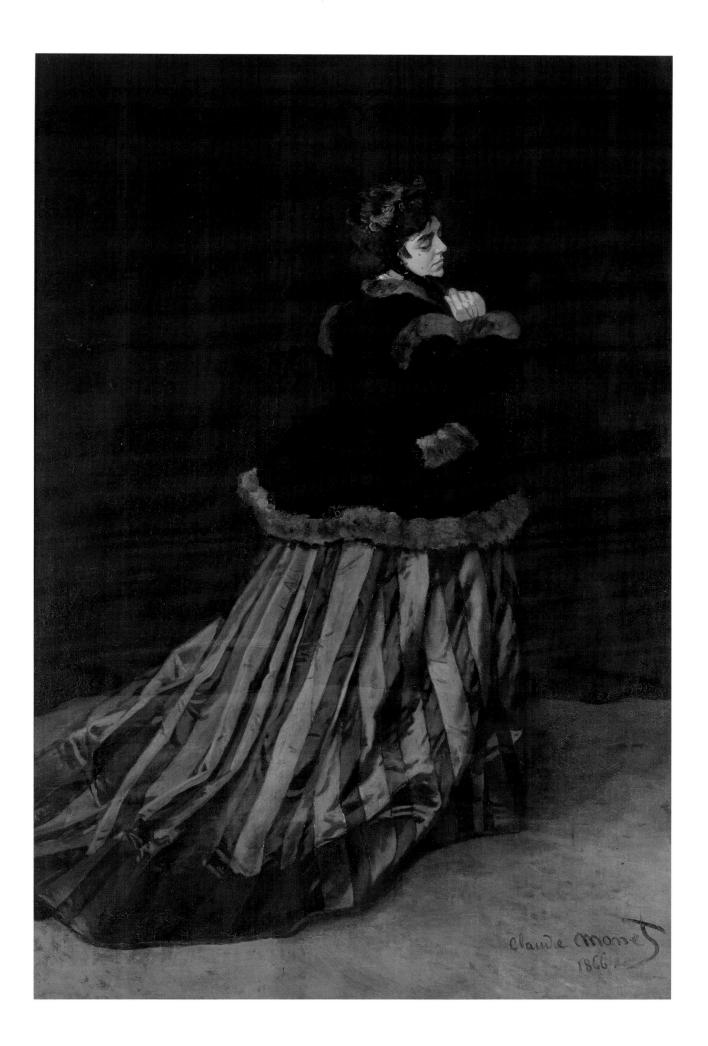

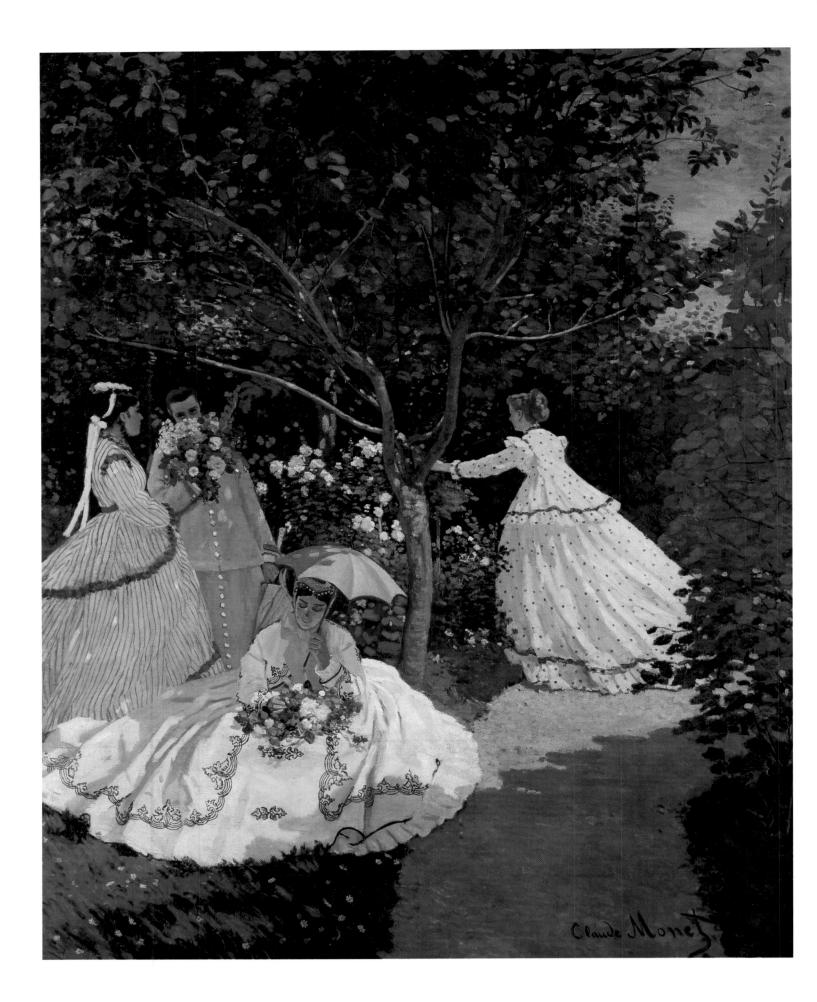

Monet Finds his Subject Matter

Monet was unstoppable. Spurred on by his first Salon successes, he continued his work on figure painting – small wonder, given the belief among jury, critics and public that the human figure was everything and landscapes little better than nothing at all. Emile Zola wrote that it was every artist's dream to paint lifesize figures in a landscape; and certainly it was a dream Monet dreamt. He felt the *Déjeuner* debacle had taught him a lesson, and for *Women in the Garden* (p. 16) he took a more manageably sized canvas out into the open rather than transferring sketches to a large format in the studio. Even with a canvas measuring two and a half metres by two, though, it was no easy undertaking, and fellow artists such as Courbet poked fun at him when they stopped by – small wonder, given that Monet had dug a trench to accommodate the lower part of the painting while he worked on the upper.

Again Monet failed. He finished the picture, true; but the Salon jury turned it down, and posterity too has agreed that (unlike somewhat later works that were also rejected at first) *Women in the Garden* is not altogether successful. The figures do not seem a part of the natural scene; they are like dummies in a garden. Camille, with palpable patience, sat and stood for all the figures. She seems frozen in her poses, and the woman on the right is gliding across the ground as if she had a trolley concealed beneath her dress. The presence of the women in the garden seems curiously unmotivated, Monet's interest in their individual psychology nil. This painting is a far cry from the charismatic *Lady in a Green Dress*.

Nonetheless, the painting has a fascination that makes it unique in its time, and that is its use of sunlight, spread like a great towel on the path. Monet emphasizes the whiteness of the flowers, the shadows falling boldly across the gown of the woman in front, the silky glow of her face where sunlight falling through her parasol meets light reflected from the sheeny dress. He has endowed his picture with life – not the life of people but the life of shadow and light. The freshness of his treatment was new, and the contrastive force with which he presented his figures in the open had an unconstrained power. In Manet's *Déjeuner sur l'herbe* (p. 12), by comparison, the people might as well be posing in a photographer's studio. It may be that *Women in the Garden* revealed Monet's subject to him for the first time: light.

The following year, 1867, he painted in Paris with Renoir. His view of the Gothic *Church of Saint-Germain-l'Auxerrois* (p. 18) was done from the second floor of the Louvre in glaring morning sunshine. *The Garden of the In-fanta* (p. 19) was likewise painted from the Louvre, but this time in overcast

Monet studied the Paris fashions carefully in order to record contemporary life accurately. As with *Le déjeuner sur l'herbe*, he used magazine illustrations to help him with *Women in the Garden*.

Women in the Garden, 1866

Church of Saint-Germain-l'Auxerrois, 1867 The pictures Monet painted in spring 1867 from the balcony of the Louvre were homages to the lavish style of the metropolis Paris had recently become. In contrast to Manet and Degas, though, Monet remained interested in the city only for a limited time.

The Garden of the Infanta, 1867

conditions. Details and modish accessories no longer interested Monet: the figures he now peopled his scenes with were mere dabs and strokes, not intended to tell any story or present the latest fashions but merely there to articulate spatiality and receive the light.

Both paintings show the new, modern Paris. The square in front of the Gothic church, with its young chestnut trees, had but recently been laid out; and the buildings in both pictures remind us that radical urban reforms lay only a few years in the past. In those Second Empire years, Paris was creating the cosmopolitan urban profile it retains to this day. The crooked lanes and mediaeval alleys of the old quarters had been demolished to make way for the majestic neo-baroque of the avenues and monumental buildings created by Napoleon III's urban planner, Baron Haussmann, engineer of an ambitious new order in Paris. The city became lighter, more spacious and stylish than it had been. The changes admittedly had startling social consequences, making a handful of property speculators rich and banishing many of the poorer traditional population of Paris to the suburbs; but they also prompted a prosperity and splendour that the young artists evidently found

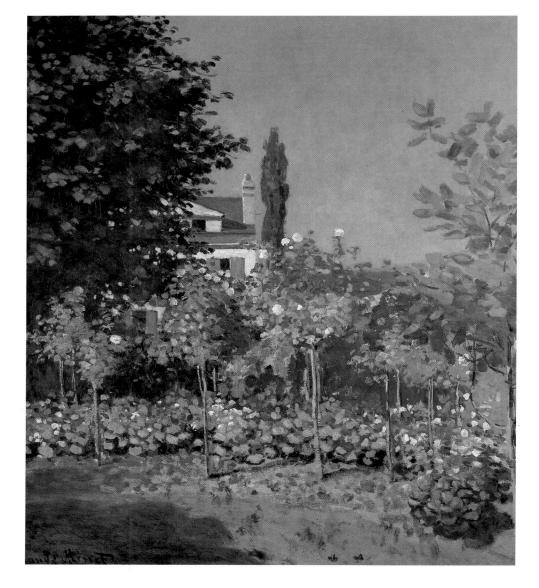

attractive. Thus Monet too painted the new metropolis with its carriages and its promenading citizens.

He himself, it is true, had little share in the prosperity of the time. Repeatedly rebuffed by the Salon, without any dependable patron, he struggled to get by on occasional commissions and the support of friends. His family refused him an allowance, disapproving of the fact that he was living with Camille, a woman of humble origins. Bazille, who was better off financially, frequently took Monet under his wing, sharing his own studio with him and even buying Women in the Garden. He paid 2,500 francs for it - a high price for a work by an unknown – and doled the money out in monthly instalments of 50 francs. This well-meant patronage was still not sufficient for Monet's rent, food and painting materials, though – so he pretended to his family that he and Camille had separated. They promptly reinstated him, and he spent the summer of 1867 at his aunt's country house at Sainte-Adresse, writing to Bazille of his concern and asking him to look after Camille, who had stayed in Paris. Camille was pregnant, and on 8 August gave birth to their first son, Jean. Monet remained in Normandy, playing the family part expected of him in the hope of assuring the support of his relatives. "For two weeks," he wrote to Bazille on 26 June, "I have been in the bosom of my

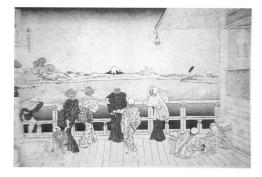

Katsushika Hokusai: The Sazai Pavilion at the Temple of the Five Hundred Rakan, 1829–33

The exceptionally compact composition of *Terrace at Sainte-Adresse*, arranged in horizontal layers, is better understood if we bear Monet's inspirational debt to a very popular Japanese woodcut in mind.

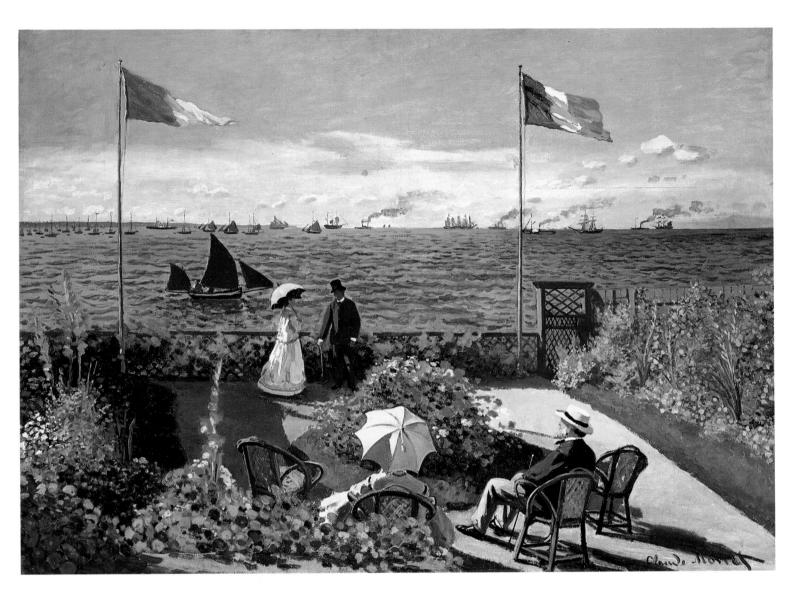

family, and am as happy as is possible. They are all nice to me, and go into raptures at every brushstroke. I have a good deal to do, about twenty seascapes, figures and gardens."

Gardens were to engage Monet his whole life long. He had hit upon this theme the year before at Sainte-Adresse, and was gripped by the colourfulness and opulence of flower gardens. The gleam and luxuriance of gardens allowed him a pretext to pursue the power and effects of light and colour to the full. The sunlight in Garden at Sainte-Adresse (p.20) awakens colour from the earthen sleep it had been kept in by realist art, with luminous red heightened by white and especially by the lush, rich complementary green. In Terrace at Sainte-Adresse (p. 21) the flowers and light have been combined with Monet's first subject, water. This picture was probably painted in the same year as Garden at Sainte-Adresse, and the figure in the foreground, as Monet later reported, is his father. The brushwork is not as relaxed as in the Paris paintings, and the figures, as well as the terrace and the sea, are oddly stiff and schematic; but still, in its use of sunlight the painting goes beyond Women in the Garden. For the first time, Monet was painting colourful shadows; and his flowers, with a greater freedom than before, are rendered with loose dabs of luminous unmixed colour.

Terrace at Sainte-Adresse, 1867

Monet binds the sunlight, sea, figures and flowers into a composition that must have seemed daring at the time. His use of colour and his brushwork, though, were still closer to his earlier realist mode than to Impressionism.

The River, Bennecourt, 1868

Monet has used the reflections in the water to move in an abstract direction. Nature and its mirrored double become a single unity patterned across the canvas in a spirit detached from spatial illusion.

Monet's Salon debut had been as a painter of the sea, and he remained fascinated by it throughout his life – not only by stylish resorts and regattas, but above all by the waters, tranquil on sunny windless days, wild and stormy at other times, or broodily overcast. He also loved to paint lakes and ponds, and, time and again, his river, the Seine. In all of this he studied not only the shifting weather moods and shapes of water (p. 23) but also its properties as a reflective surface that split and reassembled landscape features. On the water's mirror surface, the sky and clouds, houses and trees, people and boats became a two-dimensional image free of corporeal, spatial substance. A painting such as The River, Bennecourt (p. 22) demonstrates that, for Monet, water was a means of abstraction. Areas of colour - scarcely distinguished by representational function - give the picture a rhythmic structure. The mirror of the water surface blurs the spatial dimensions of landscape art, thus taking a significant step toward non-representational, abstract art. Monet was to take this principle, apparent in early works such as this, much further in his late water landscapes, his paintings of cliffs, and above all his famous waterlilies.

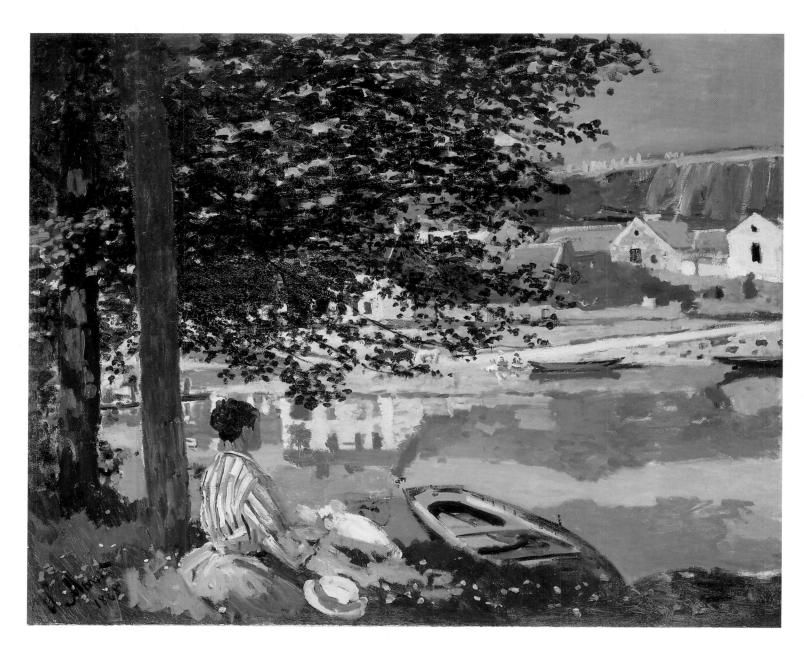

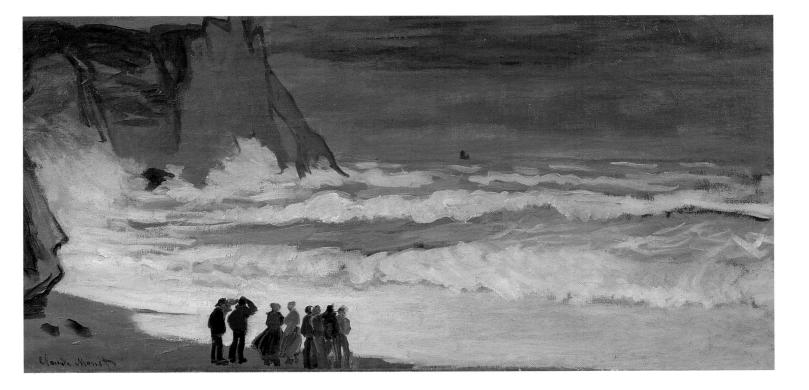

But there were many years to go before that radical stage was reached. They were to be years in which Monet tried time after time to create compositions filled with traditional kinds of tension, and to locate picturesque views. And they were also years of poverty, even of despair. Needless to say, he could not keep up his charade indefinitely, and could not neglect his lover and son any longer. He returned to Paris, to face renewed official rejection of his paintings, and the struggle for mere subsistence. Bazille was often his only source of support. Countless letters in which Monet approached his loyal and generous friend for money have survived to document his predicament. The following autumn, the situation eased for a while when he met a Le Havre shipping magnate named Gaudibert. Monet painted a number of portraits, including one of Madame Gaudibert, and for a time his mood was calmer. In December 1868 he wrote to Bazille in Paris: "Here I am surrounded by the things I love. I spend my time in the open, on the beach in stormy weather or when the fishing boats put out... In the evenings, my dear friend, there is a warm fire in my cottage, and the cosiness of a small family. If only you could see how cute your godson is now! Thanks to the help of the gentleman in Le Havre, I am now enjoying a spell of quiet, free of chores. Ideally I should like to stay in a peaceful nook like this for ever." But the idvll was to end abruptly that very year. Monet had to flee his creditors, and returned to Paris, leaving a great many paintings behind in Le Havre. His concentration on gardens, water and light was diminishing his prospects of sales, and indeed of official recognition. Light, flowers and water were taking the young artist further and further from the Salon.

Stormy Sea at Etretat, c. 1873

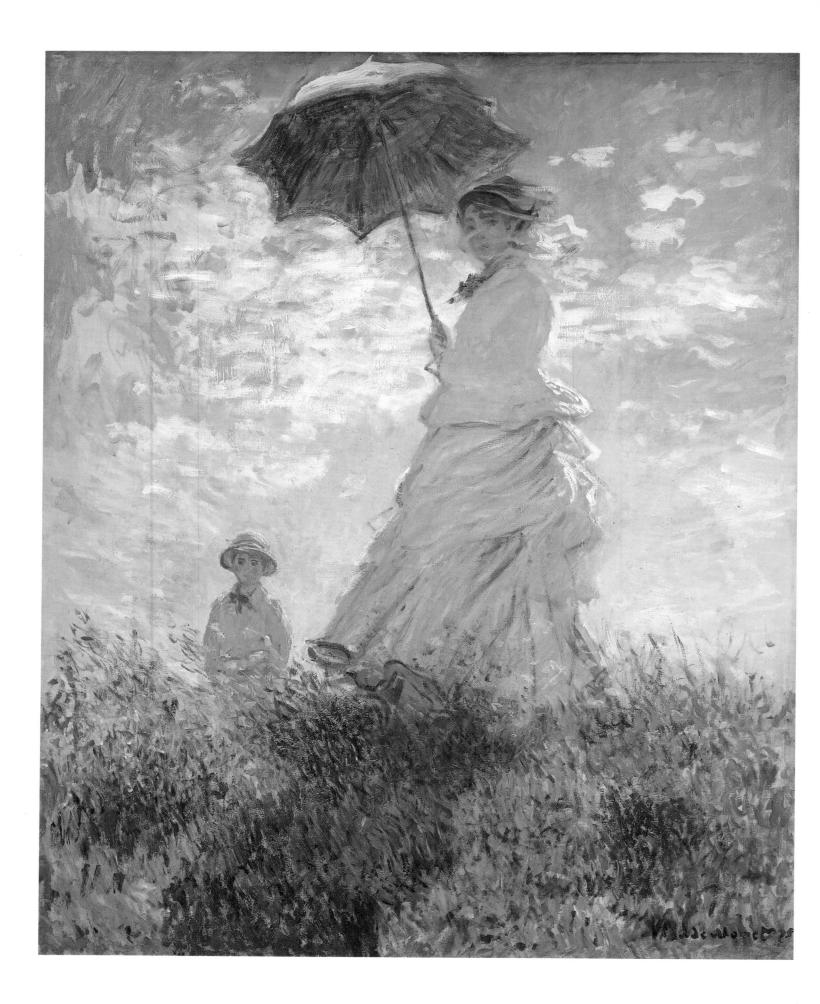

The World as a Month of Sundays

From Boudin, who encouraged him to paint out of doors, Monet had learnt that whatever was painted on the spot, in the open, possessed an energy and vitality in the brushwork that were unattainable in the studio. An artist working in a studio could fall back on academic conventions and his own repertoire of mannerisms, but painting en plein air compelled continual response to the changing atmosphere and light. Painters of every period had of course done sketches in the open, recording the phenomena of Nature in pencil. chalk or watercolour, and since the late 18th century even in oils; but these were merely sketches destined for transfer to canvas in the studio, where academic rules would govern the creation of a traditional composition. What was new in art now, indeed revolutionary, was the principle of going out in the open with easel and canvas, palette and oils, to draft and work on paintings out of doors and perhaps even to finish them there. Monet was one of the first to move his studio outdoors in this way. The recent invention of tubes for oil paints was a significant contributory factor, since mixing paint powders and oil in the open (certainly in the blustery winds of Normandy) would have been a tall order. Painting out of doors remained a complicated, uncomfortable business at all times, in any case. Monet would set off on summer days laden with his painting paraphernalia and a large parasol to keep direct sunlight off his canvas. At colder times of the year he could be seen in boots and woollens and several layers of coats and blankets, busy sur le motif. When a wind was blowing he would tie his easel and canvas fast with cord, but even so Nature played its pranks on him, and on one occasion, when he had mistaken the times of the tides, a freak wave washed him into the sea, together with all his utensils and canvases. "Art demands bravery in its soldiers," mocked one contemporary critic.

To get out of the city centre, further than the park, with all one's oils and canvases, would have been a complex affair in itself just a few years earlier, requiring the use of a carriage or cab, and thus presupposing a certain level of prosperity in the artist. But the rail connections that had been established since the 1850s meant that villages close to Paris were now even closer, and even poor artists could afford to go out into the country. Trains left the Gare de l'Est hourly for Argenteuil, Bougival, Asnières and other villages along the Seine; and the capital was only a few hours from the stylish seaside resorts of Deauville, Honfleur and Trouville. Painters travelling out to work would share their compartments with trippers from every walk of life. For the first time in history, urban working populations and the lower middle classes were in a position to take trips, shaking the city dust from their feet

Antony Morlon:

La Grenouillère (detail), 1880–90 City dwellers at their leisure in the country. Excursions à *la campagne*, once the privileged preserve of the nobility and upper classes who owned carriages and horses, were now affordable to all, thanks to the railways.

The Walk. Lady with a Parasol, 1875

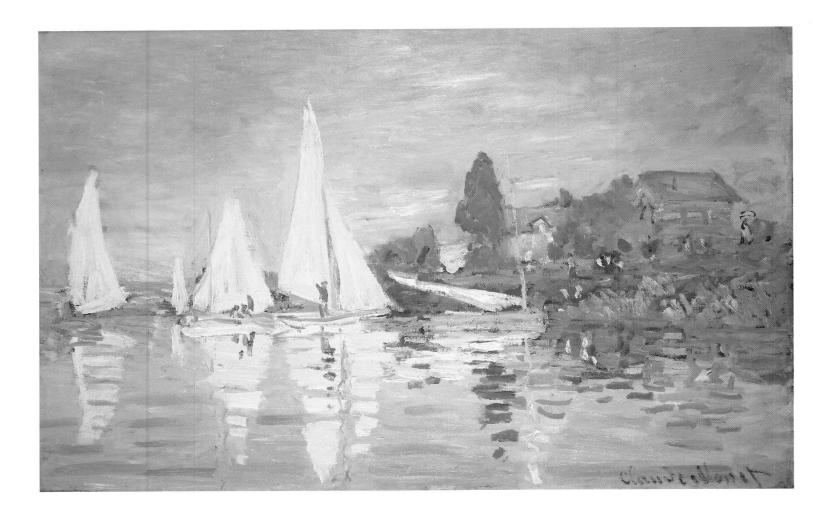

Regatta at Argenteuil, 1872

Hôtel des Roches Noires, Trouville, 1870

- at least for a day. "When I set off I said to myself: And there I shall have some air, some sun and greenery! ... Oh, yes, greenery! Instead of cornflowers and poppies, great prairies covered with old clothes and detachable collars... laundresses everywhere and not a single shepherdess. ... Coach drivers who jeer at you, restaurateurs who take you for all they can get... forests where you lose your daughter... hotels where you mislay your sonin-law! ... And that, my dear Joseph ... that is the faithful description of what are customarily called... the Environs of Paris!..." Thus the good Monsieur Bartaval, the hero of an *opéra bouffe* in 1875, describing a weekend in the country. The satire and cartoons of the day described the denaturing and industrialization of the small towns along the Seine, and their transformation into day-trip resorts for the urban population, during the Impressionist period. "Wherever there was a wretched square of grass with half a dozen rachitic trees, there the proprietor made haste to establish a ball or a caférestaurant."

In summer 1869, Monet and Renoir painted one such day-trip resort at Bougival, *La Grenouillère* (i.e. the Frog Pond; pp. 28/29). The two artists adopted almost the same line of vision, Renoir probably standing a little to Monet's right and perhaps somewhat closer to the water. Both took as their subject the pleasure-seekers on the Flowerpot (as the tiny bathing island with its one tree was known). Both were plainly at pains to be topographically exact; but this very similarity also serves to focus the differences in the two artists' styles. Monet constructs his picture using clear, horizontal brush-

strokes, using his highlights sparingly but forcefully. His brushwork is energetic, whereas Renoir's paint has an airily hazed look to it. Monet's colours are few, muted and cool, but Renoir's palette is a more tender thing, warmer through its inclusion of reddish hues. Monet is not interested in fashions, so his figures are no more than brushstrokes, whereas Renoir, for his part, is engaged by the material qualities of clothing in sunlight, and has an eye for' modish details. Renoir's composition, with its central focus, conveys a cosy sense of intimate confinement, while Monet, evenly distributing his shadows and placing his white light emphatically at the margins, dissolves the central focus and instead establishes a broad, dynamic feel across the entire visual field, creating a harmony between the surface patterning

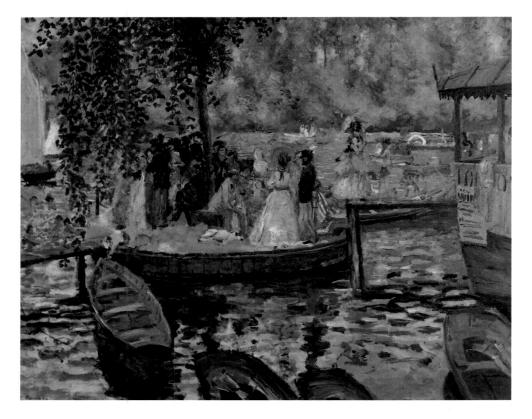

Miranda: *La Grenouillère*

La Grenouillère (or the Frog Pond) was a popular spot that took its name not only from the frogs. "Grenouilles" were young women whose favours were bestowed for hard cash.

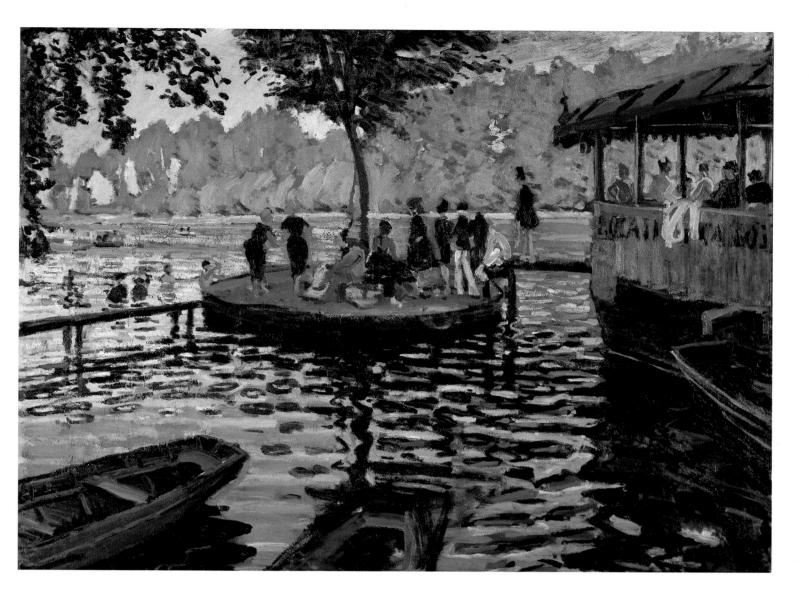

and the spatial depth. This transfer of tensions towards the margins is characteristic of Monet's compositional approach. If we compare *The River, Bennecourt* (p. 22) or *Terrace at Sainte-Adresse* (p. 21), we see that in *La Grenouillère* Monet has succeeded in capturing the material properties of the water surface while still allowing it functions of a patterning kind. It is a work in which we see his art losing the last of the stiffness which had given *Women in the Garden* (p. 16) or *Terrace at Sainte-Adresse* something of the appearance of opera backdrops.

Sunny scenes like that at La Grenouillère had a long tradition that had peaked in the gallant art of Antoine Watteau. The Impressionists, and Renoir even more than Monet, were continuing that Arcadian tradition, but instead of a secluded idyll the scenes they painted were full of the kind of bustle Monsieur Bartaval described. Monet's bathing and regatta scenes present an early stage of the leisure industry which enables city dwellers to consume what Nature makes available. These pictures of Sundays in the country, like paintings of modern life in Paris, were more than merely contemporary: they constituted a deliberate attempt to record what was definingly modern about everyday life in Monet's day.

From our own point of view, it is hard to understand why these paintings

La Grenouillère, 1869

The small circular island with its single tree was nicknamed the "Flowerpot" (or the "Camembert"), and for Monet and Renoir it provided an attractive subject for early "Impressionist" work. Easel by easel they worked on the same subject – and their paintings, similar though they naturally are, reveal the fundamental differences between the two artists. of recreation and Sunday pastimes should have met with such harsh criticism, and been so unbendingly rejected by the academy and the public alike. Three factors must have influenced this response: the painting technique, the handling of colour, and the approach to the human figure. In trying to set down their immediate impressions of light and colour, the Impressionists evolved a brushwork technique all their own. They used relaxed strokes and comma-like dabs, juxtaposing brighter tones with contrasting, darker yet still colourful shades without any modulation of intermediate colours in between. This technique would have been widely accepted in an *ébauche*, or sketch, but quite different accomplishments were expected of a *tableau*, or finished painting; and the Impressionists were felt to be failing the tests of

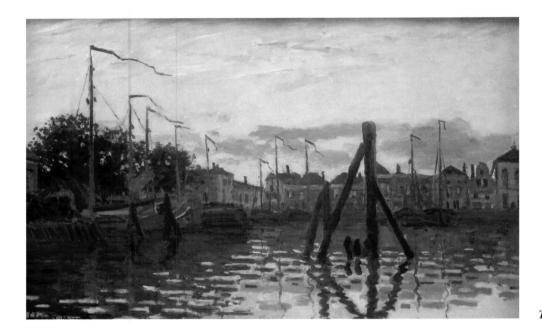

The Port of Zaandam, 1871

skill that artists were expected to pass. The fact that the size of their compositions suggested they were to be considered finished was felt to be particularly presumptuous. Furthermore, the public was used to the earthy tonalities of the Naturalists, or the cool metallic values of Ingres and his disciples, so that the gleaming splendour of Monet's art appeared a glaring, loud provocation. Ingres's influence on academic art at that time was decisive, and he had made draughtsmanship the fundamental requisite of painting. A pupil of the classicist Jacques-Louis David and an ardent admirer of Raphael, Ingres had stressed clarity of outline, tender subtlety of colour, and amply weighted contouring, and the delighted bourgeoisie rewarded him with endless portrait commissions. The criterion for quality in a painting was the clarity of outline, schooled on antiquity, and its elegant grace. "Draw lines, lots of lines," was the imperative that Ingres used to din into his pupils. Colour was no more than an extra in his eyes. Ingres, and a majority of academic artists, fought a lifelong war against Delacroix, who rated colour above all and (like Courbet and Manet later) had a long struggle to gain admission to the Salon at all. But even the dramatic chiaroscuro of a Delacroix - its lines and colours plunging from nowhere into the centre in order to establish a figure

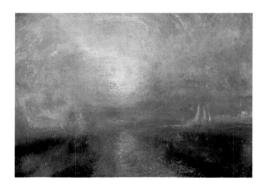

J.M.W. Turner: Yacht Approaching the Coast, 1838–40 In London, Monet was impressed by the atmospheric virtuosity of Turner's art, and its approach to form and light. The British painter was one of the major influences on Impressionism.

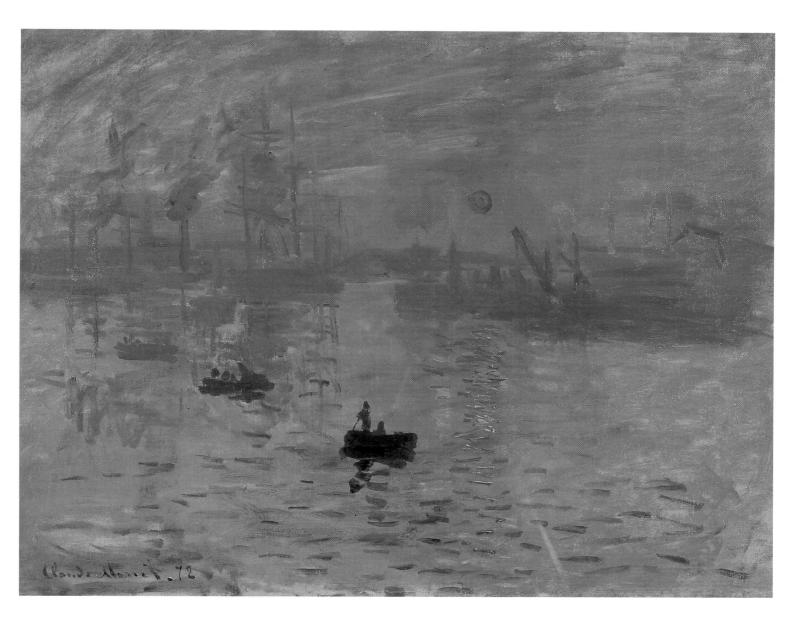

there as if by chance – had an almost old-masterly air when compared to the comma-like brushwork and luminous, spectral colours of the Impressionists.

If we consider the high valuation which was commonly placed on figure painting, the manner in which Monet and his fellows tackled the human figure must have been particularly vexing to their contemporaries. Academic painters would portray a bourgeois gentleman as Leonidas or Odysseus, and his madame as the beautiful Helen or virtuous Diana. They were cloaked in the ennobling robes of antiquity. The good citizens who appeared out for strolls in Monet's paintings, however, were mere ragged flaps of stuff, like pennants when the breeze dies. Like clumps of grass or clouds of smoke, Monet's people served simply as surfaces on which light could play. "Are you telling me that that is what I look like when I stroll along the Boulevard des Capucines?" demanded the critic and genre painter Louis Leroy in the satirical magazine *Le Charivari* when *Boulevard des Capucines* (p. 33) was exhibited at the first joint Impressionist show in April 1874. "The devil take it! Are you taking the mickey?"

For ten years, the younger artists had been continually barred by the official world. Now they decided to take matters into their own hands. Monet, Renoir,

Impression, Sun Rising, 1873

This atmospheric morning scene in the port of Le Havre gave the new movement its name. Critic Louis Leroy derisively dubbed the new artists Impressionists, adding: "Wallpaper in its raw state is more finished than this marine picture."

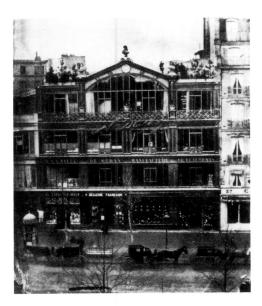

The new artists' society's first group show opened on 15 April 1874 in the old studio premises of Nadar, the famous photographer, in the stylish Boulevard des Capucines.

Boulevard des Capucines (detail)

ILLUSTRATION PAGE 33:

Boulevard des Capucines, 1873 Monet rendered the constant flow of passersby along the boulevard as a flickering impression of haze and light, done in vibrant dabs of paint. As we look at the painting we receive an overall impression without registering individual figures or details. Pissarro, Sisley, Degas, Cézanne, and a number of others, founded the *Société anonyme des artistes, peintres, sculpteurs, graveurs, etc.* in order to display their work independently of the Salon. Their first exhibition was far from a success with the public, though. Eight to ten thousand visitors crowded to the Salon every day; the Impressionist show drew a mere 175 on its first day, and on the last just 54, most of whom were in fact there to poke fun at the art exhibited. It was that show, though, that got the new movement its name. Louis Leroy's article in the magazine *Le Charivari* was headed "Exhibition of the Impressionists", and in it, borrowing a word from the title of Monet's sea piece *Impression, Sun Rising* (p.31), he damned the new art roundly: "Impression – too right! And I was just saying to myself that if an impression has been made on me, something must be making it. What freedom and ease in the brushwork! Wallpaper in its raw state is more finished than this marine picture!"

In this famous picture, Monet used delicate strokes of thinned paint to record his impression of morning at the harbour of Le Havre. With a few succinct, audacious strokes he juxtaposed the orange reflections of sunlight with a variety of greys. The ships' masts and chimneys, though hazed by mist, nonetheless constitute a graphic compositional fabric of verticals and diagonals that lends structure and vitality to the field. His loose brushwork, the sketchiness and immediacy with which he recorded the perception of a single moment, struck the public as a scandal, and was felt to be brutally coarse.

The Impressionists were initially so called in a spirit of ridicule, but the label stuck, and within days of Leroy's barbed article in *Le Charivari* a well-disposed critic was writing: "If their aims were to be described in a single word, we should need to coin the word Impressionists. They are Impressionists in that they do not reproduce a landscape but convey the impression it makes on the beholder."

Nowadays we do not perceive Impressionism as constituting a revolutionary new departure, or the achievement of a single artist; rather, we view it as a further development of ideas, techniques and observations that recurred throughout the first half of the 19th century, even if it was left to Monet and his fellows to apply them with full radical rigour. An impression was the visual impact made by a landscape or other motif in a single moment. The eye does not consciously register all the available detail in a moment; it is only by gazing at buildings, passers-by or other things for longer that we see individual windows, decorative features on façades, a fashionable hat or a dignified face, and in the course of this longer scrutiny the brain catches up with the eye, erasing the first impression and substituting the sum of experience, conventional perception, or imaginative projection. What the Impressionists in general, and Monet in particular, aimed to preserve was the visual freshness of that first fleeting moment, free of categories of perception or traditional precept. When Monet opened his eyes he saw blocks of colour, surface patterns, the very air, as defined by light; and the impressions he received were his subject matter on canvas. "He was only an eye - but what an eye!" Paul Cézanne famously remarked of Monet; and his words aptly pinpoint his fellow artist's central concern. What Monet was to call l'instantanéité became his life's work, and time and again reduced him to despair, for there is an intrinsic and irresolvable contradiction in the aim to preserve in permanent form the passing moment.

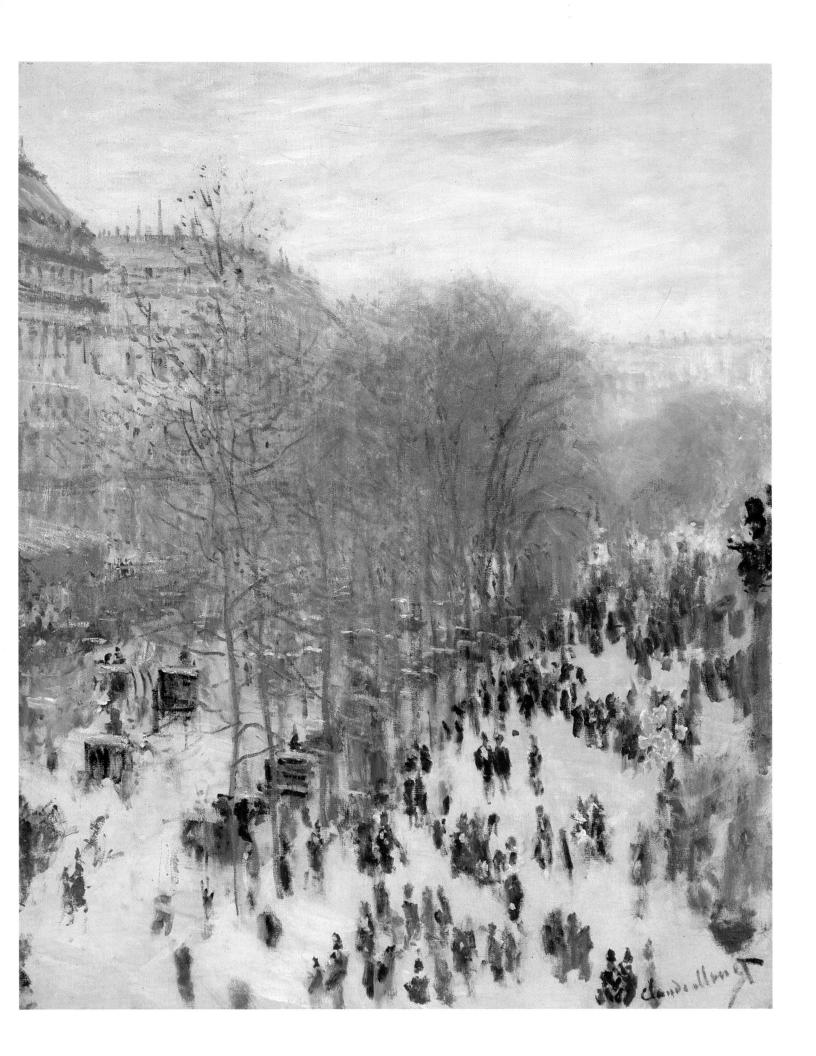

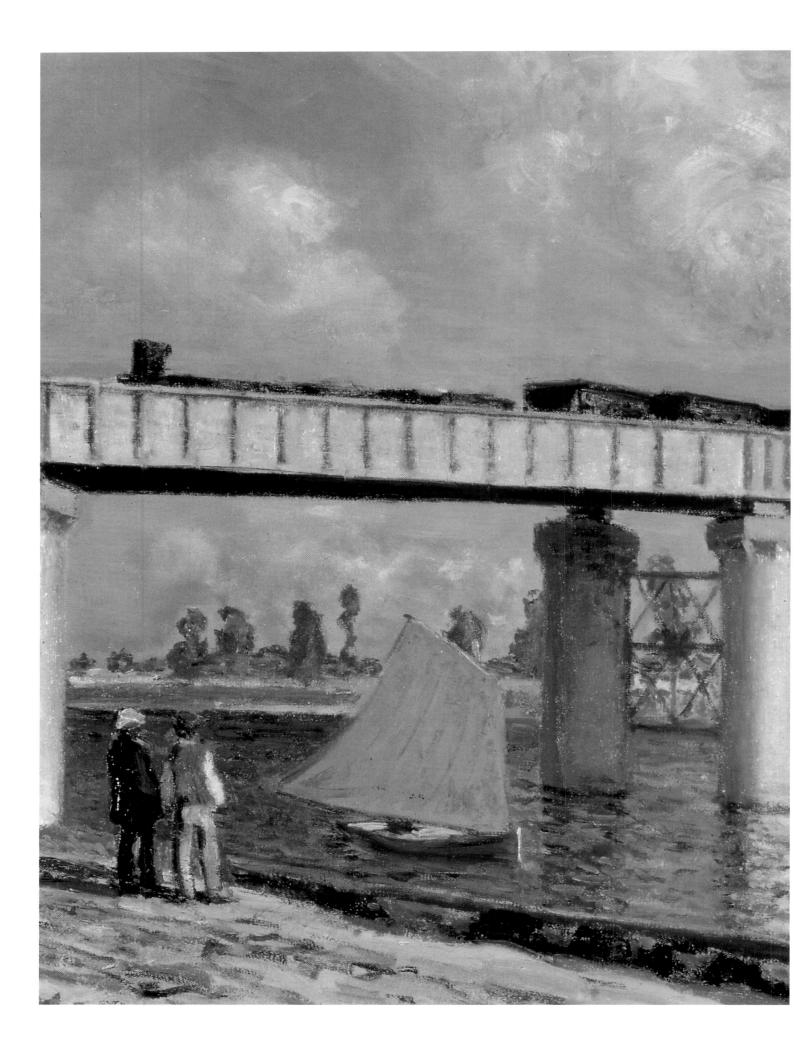

The Bridges at Argenteuil

Ladies in rustling dresses carrying dainty parasols, society people enjoying picnic lunches in the woods, or bathing pools at Bougival, generally appear to us now as if through the prettifying spectacles of nostalgia. To Monet's contemporaries, though, this subject matter was the height of modernity. The new generation of artists set out expressly to be of their time, an aim that put them at odds with academic predilections for the heroes of antiquity or mediaeval romance. Few of them were as consistent in their wish to record the spirit of the age as Monet. We can gauge his consistency by the startling amount of common ground between his early figure paintings, for instance, and the illustrations in contemporary fashion magazines. We can see it in his homage to the modern profile of Paris, in his smoking chimneys at Le Havre, or in his portrayals of modern leisure activities.

In autumn 1871, after the Franco-Prussian War (during which he had lived in London to avoid conscription), Monet moved to Argenteuil. The year before he had married Camille, and now the couple, with their little son Jean, rented a house and garden outside the city. Argenteuil, about ten kilometres north-east of Paris, was described at the time as "a very pretty town, pleasantly situated on a low hill where the vineyards slope down to the right bank of the Seine". Like Bougival and Asnières, it was a popular spot for Parisian weekend excursionists. It offered sailing regattas with stylish city crowds, restaurants, cafés and bathing spots, as well as unspoilt poppy fields or rowing boats idling in the sun – in a word, a cornucopia of motifs to tempt artists. In the years ahead, Argenteuil was to be the favourite patch of the Impressionists.

Apart from brief visits to Holland and Normandy, and of course Paris, Monet lived and painted at Argenteuil till he moved to Vétheuil in 1878. Camille's dowry, and the money Monet inherited on the death of his father, enabled them to lead a more comfortable, prosperous life for the first time. Moreover, Monet was now receiving support from the art dealer Paul Durand-Ruel, whom he had met in London. Durand-Ruel regularly bought Monets, despite the initial difficulties in re-selling them.

From letters and meticulously kept account books we have a fairly clear picture of the Monet family's life. Till mid-decade, at least, they were well off, even affording two servants and a gardener. The circumstances and life-style of the *bonne bourgeoisie* were apparent in intimate paintings such as *The Luncheon* (p. 36), which shows Camille and little Jean in a well-tended summer garden. On the table with its white cloth are costly Chinese teacups and a silver pot, while the summer gowns of the ladies, and the straw hat

The Railway Bridge at Argenteuil, 1873 The bridge is a utopian monument to the new, modern age in Monet's painting. It carried city leisure-seekers out to the country but also encouraged the settlement of new industries out in the suburbs.

The Railway Bridge at Argenteuil (detail)

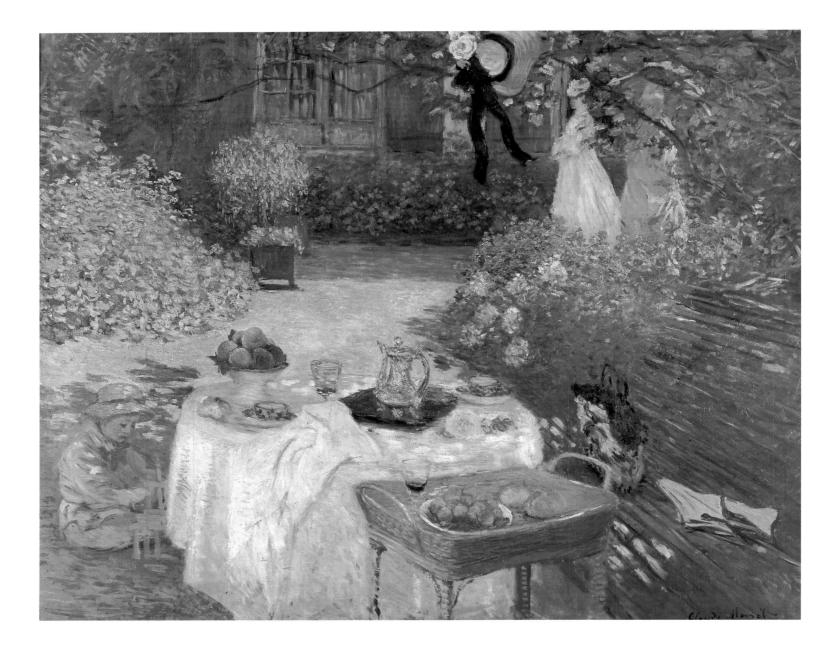

hung on a branch, suggest the kind of leisure which in turn presupposes a certain affluence. *Jean Monet in the Artist's Home* (p. 37) affords us a glimpse of the shady interior of the house, and here too the chandelier, waxed parquet floor, and little Jean's sailor costume, all serve as reminders of the Monets' prosperity at that time.

Monet cultivated dealers and collectors, and also liked inviting friends to stay. Renoir and Pissarro were visitors, and Manet, who had jeered at *plein-air* painting for years, became a convert at Argenteuil. It was there too that Monet met Gustave Caillebotte, a painter who was financially independent, thanks to a legacy, and who, over the next few years, was to become one of the first important collectors of Impressionist art. Caillebotte helped out Monet and his fellow Impressionists time and again, and paid for their exhibitions. When he died in 1894, his collection – which included sixteen works by Monet alone, among them major paintings such as *Gare Saint-Lazare* (p. 41), *The Luncheon* (p. 36) and *Regatta at Argenteuil* (p. 26) – passed to the French state; but it was a long time before official quarters could bring

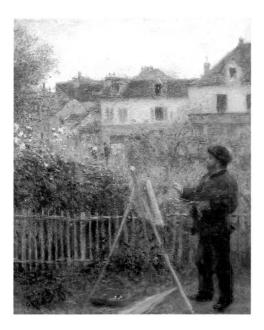

themselves to exhibit at least a part of the collection. The Caillebotte bequest was the cornerstone of the Louvre's Impressionist collection, now on show at the Musée d'Orsay.

At Argenteuil, Monet took to the water. He added a cabin to a broad rowing boat, and an awning to keep off the sun, and used it as a floating studio. This had originally been an idea of Daubigny, the landscape artist, who had painted on the Seine and the Oise in his *botin* fifteen years before. Monet's studio boat can be seen in a number of his paintings, and was also painted by Manet in 1874 (p.38), who showed Monet painting a river scene on the water, literally *on* his motif. Monet was capable of conveying the wind in the reeds, or the tranquil flow of water, with an immediacy that is altogether absorbing. *The Bridge at Argenteuil* (p. 40) and *Poppy Field at Argenteuil* (p. 39) demonstrate that painting *sur le motif* presented the artist with landscapes that were open-ended in every direction.

ILLUSTRATION PAGE 36, TOP: *The Luncheon*, 1873

ILLUSTRATION PAGE 36, BOTTOM: Auguste Renoir: Monet Painting in his Garden at Argenteuil, 1873

Jean Monet in the Artist's Home, 1875 The first few years at Argenteuil were a magical time for Monet and his small family. Financially secure for the time being, he settled into a relaxed life in a pleasant house and garden, painting some of his brightest pictures. Argenteuil was not only a leisure resort. Since the mid–19th century it had been increasingly industrialized; and, for the Impressionists, this constituted an additional attraction, since industry betokened modernity. Argenteuil was linked to the city by two bridges, and Monet painted both. The older of the two (p. 40), originally built of wood and stone, had been destroyed in the Franco-Prussian War but rebuilt afterwards, largely in its original state. The wooden beams were now replaced by cast iron girders, but in the reconstruction considerable emphasis was placed on giving these a decorative air, as if wrought by the craftsman's hand. The other bridge (pp. 34 and 40) was a railway bridge; and both its function and the concrete and precast iron parts of which it was built made it highly modern. Among the local people it was controversial, some seeing it as a stylish sign of things to come, others dismissing it as an "ugly roofless tunnel".

Monet's paintings vividly and instantly convey the quite distinct characters of the two bridges. His pictures of the rail bridge, seen in sharp perspective (p. 40) or bathed in cool, almost metallic light (p. 34), are eloquent of his unfeigned fascination with modern engineering, technology, industrial development – and speed, symbolized by the train. In one of the pictures (p. 34) the rail bridge is a resplendent monument to a dawning era.

The old bridge (p.40) is more peaceful in mood. In appearance it is a memento of the July Monarchy, that golden age of the affluent middle classes; and in function it is still of a traditional order, crossed by pedestrians and horse-drawn vehicles, perhaps on their way to a restaurant or bathing spot. Painted in afternoon light, it is a thing of mellow majesty, four-square and solid. Like any bridge, though, it naturally represents a conquest of Nature; it is a sign of civilization's relentless domestication of the wild. There is nothing remotely savage in the Argenteuil scenes, in fact; nor are there Arcadian idylls. Monet's Argenteuil landscapes are sunny and serene, peaceful and harmonious – without omitting the signs of the age. They are civilized.

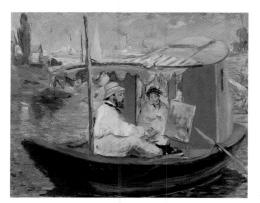

Edouard Manet: Claude Monet and his Wife in his Studio Boat, 1874 Visiting Monet at Argenteuil, Manet painted his friend working on riverbank landscapes

his friend working on riverbank landscapes from his studio boat. Camille is quietly keeping Monet company by the cabin door.

The Studio Boat, 1874

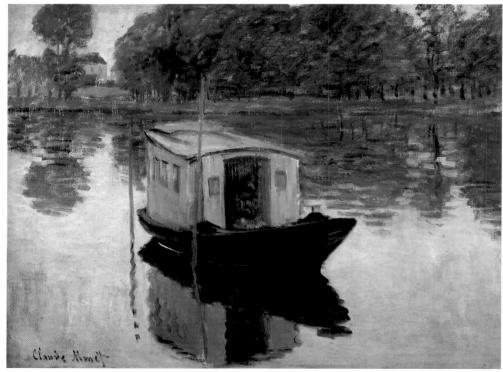

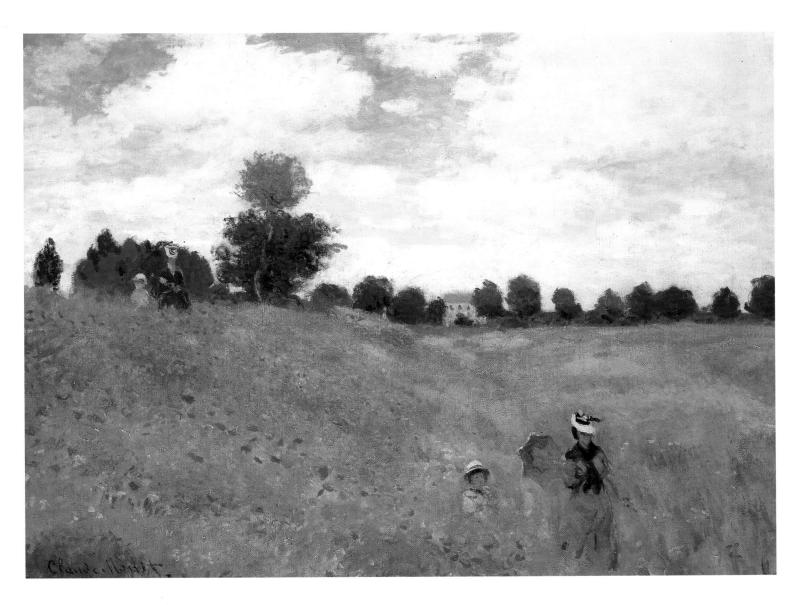

It is tempting, given the immediacy of Monet's paintings, to think of them as snapshots of a kind. But this would be to miss the structural attention that generally went into their composition. It is striking that Monet frequently used an axis to establish symmetries, an approach academic artists were careful to avoid because it tends to rob a composition of the illusion of spatial depth and draw attention to surface pattern. But it was this very property that made the principle attractive to Monet. Patterning was precisely what he was after. The Munich Bridge at Argenteuil (p. 40, top) makes this clear: Monet disposes an exact grid of horizontals and verticals, thus creating a firm surface structure for the composition. His use of colour within that structure, though, serves to re-introduce a sense of spatial depth: the pale, bright ochre of the pillars where they catch the sun is in marked contrast to the grey-green of the shaded sides, and much the same applies to the ironwork. In the water, too, there are two distinct blues: the darker serves as a ground against which the lighter is highlighted. In such ways, within a surface-patterned linear structure, the painter uses colour to create three-dimensionality and spatiality in his subject.

A similar principle is at work in the pictures Monet painted of Saint-Lazare railway station in 1877 (p.41). The station had long fascinated Monet,

Poppy Field at Argenteuil, 1873

"As a true Parisian, he takes Paris with him to the country," Emile Zola wrote of the early Monet. "He cannot paint a landscape without adding ladies and gentlemen in their finery. Nature seems not to interest him if it does not bear the imprint of our way of life." But over the years the figures disappeared from Monet's landscapes, and civilization was displaced by the direct impression of Nature.

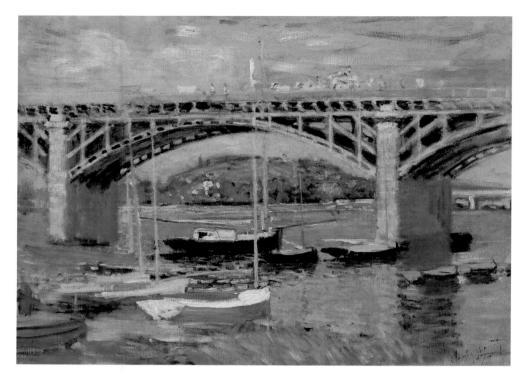

The Bridge at Argenteuil, 1874

It is a summer afternoon, and the road bridge is broad and mighty in the warm light. Through the centre arch we see the fertile hills of the Seine valley, and through the arch at right the new railway bridge.

and, if we can believe Renoir's account, he veritably took possession of it, pursuing his desire to paint it with a determination little short of insolence: "He put on his best clothes, pulled his lace cuffs to rights, and, idly swinging his gold-headed cane, handed the director of the western railways his card. The official froze, and ushered him in forthwith. The exalted personage asked his visitor to take a seat, and the latter introduced himself simply with the words: 'I am the painter Claude Monet'. The director knew nothing of art but did not dare admit as much. For a moment Monet left him twitching on the line, and then he announced the great news: 'I have decided to paint your station. For a long time I was undecided whether to take the Gare du

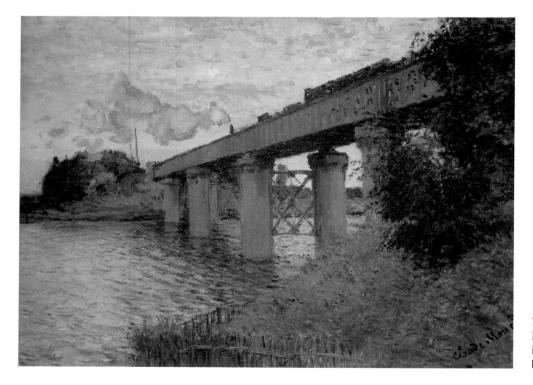

The Railway Bridge at Argenteuil, 1873 Monet painted the new railway bridge, built in the 1860s, with the light of a new day behind it.

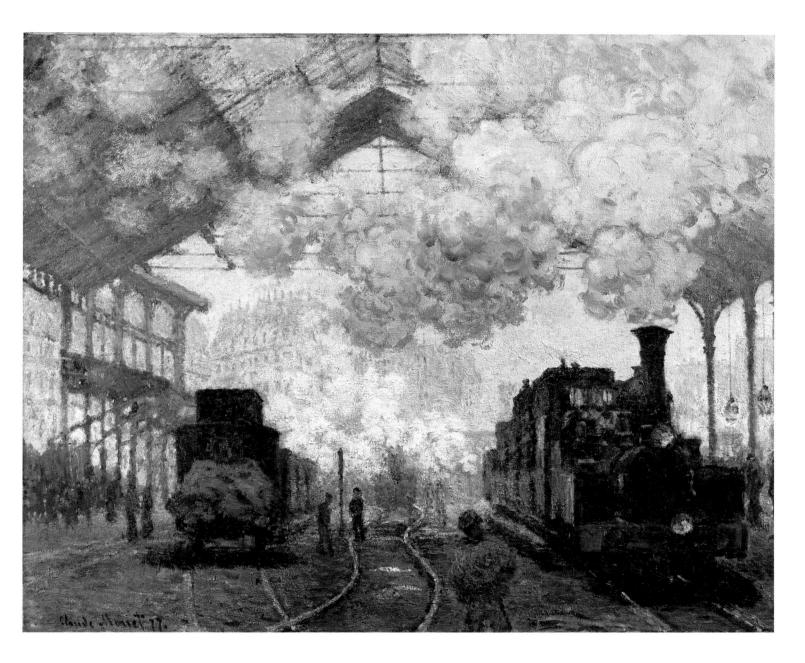

Nord or yours, but I now feel yours has more character'. Monet got his way in everything. Trains were stopped, platforms closed off, the locomotives fired full of coal so they belched out steam in that way Monet loved. Tyrannically he set himself up in the station and for days, amidst universal awe, he painted, then left again with half a dozen pictures done."

As in the pictures of bridges, in his paintings of the Gare Saint-Lazare Monet was excited by the linear structures modern engineering created. Again he used smoke, steam and sunlight to heighten the spatial atmospherics. Doubtless he was inspired in his compositional technique by Japanese woodcuts, which he had been collecting since his visit to Holland in 1871, and perhaps longer. Time and again, Monet turned to Japanese compositions for ideas. The Japanese used surfaces in ways western eyes found unfamiliar, cropping subjects audaciously and displacing major subjects from the centre, and it was these departures that engaged Monet's interest. In *Unloading Coal at Argenteuil* (p. 42) we can see clearly how he modulated individual subjects into a grid-like compositional structure. The motif establishes its distinctive and complex rhythm across the entire canvas. *Gare Saint-Lazare. Arrival of a Train,* 1877 As in the paintings of bridges, Monet was arrested by the linear structures created by the engineers. The station, full of smoke and steam and sunlight, is a cathedral of the technological era.

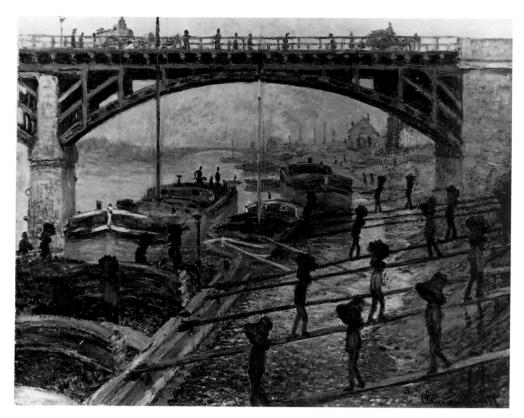

Unloading Coal at Argenteuil, 1875 This painting, influenced compositionally by Japanese woodcuts, shows the figures, walkways and coal barges as a grid-like visual pattern, establishing its rhythm across the entire canvas.

It was not till the mid-19th century that Japan had opened up to the west. Quickly, the cities of the west were swept by Japanese fads and fashions, and Monet revelled in them, as his portrait of Camille as La Japonaise (p.43) suggests. Clad in a stunning gown, its embroidered warrior looking almost alive, she is turning towards the painter. Her pose is like that in Lady in a Green Dress (p. 15), but now, rather than turning away, she is taking the time to banter coquettishly and fan herself. The Japanese fans scattered on the wall and floor seem frankly to be overdoing it. The picture can readily be seen as a concession to public taste and the Japanese mode of the day, and Monet did in fact sell it, at the second Impressionist exhibition, for a respectable 2,000 francs; assuredly its airy yet tight technique makes it a more conventional work than other paintings done at about the same time, such as The Walk. Lady with Parasol (p.24). It is worth pointing out, though, that Monet has put a blonde wig on the utterly un-Japanese Camille, and in her hand she holds a fan in the colours of the French tricolour. The picture, which Monet himself later dismissed as rubbish, is not only a break with the technique he was developing - it is also, surely, a shrill travesty of the Parisian fad for all things à la japonaise.

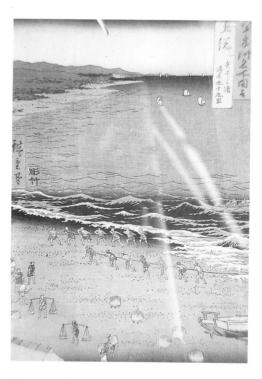

<u>Utagawa Hiroshige:</u> *The Kujukuri Coast in Kazusa Province*, 1853–56

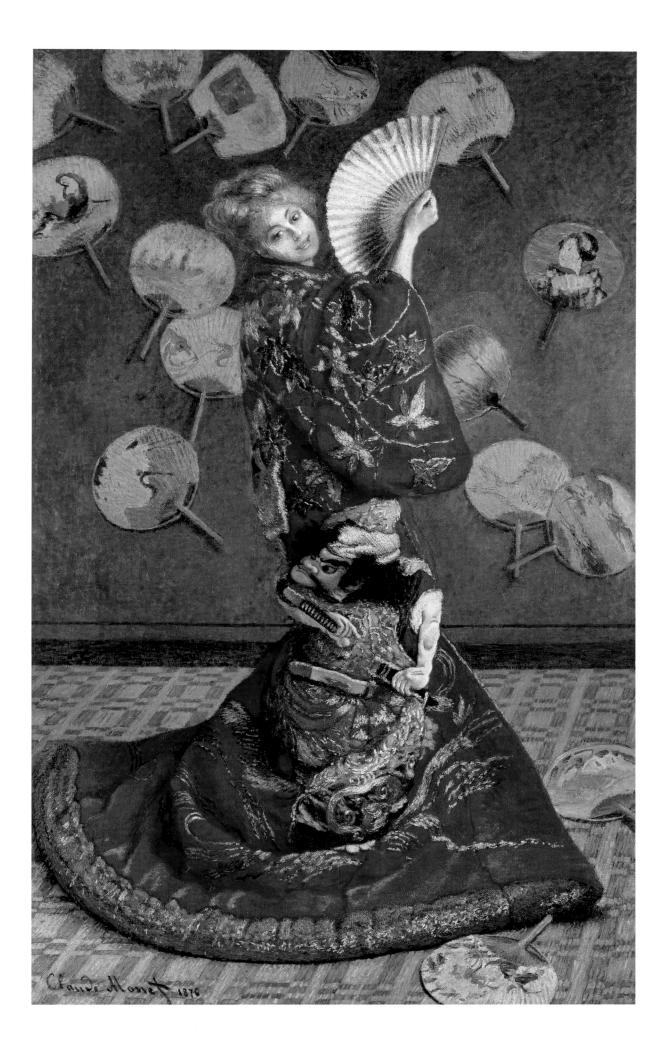

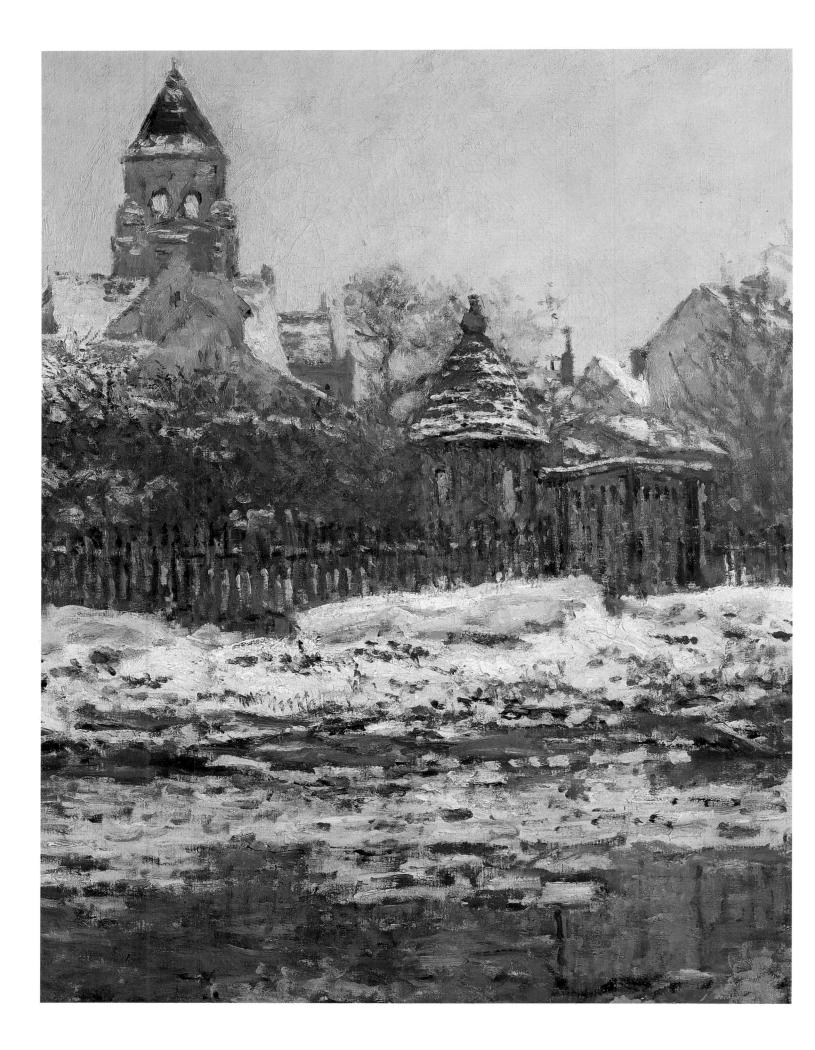

Winter at Vétheuil

The last years at Argenteuil had been a time of great financial difficulty, and this had a growing impact on Monet's motivation. Durand-Ruel's storerooms were full of pictures, and few people were buying; so he was obliged to keep new purchases to a minimum. The overall economic situation was deteriorating: there had been a brief boom, but by the mid-1870s the effects of a lost war were making themselves felt. The Impressionist group shows, held almost every year, continued to attract disappointing numbers and to be derided by critics in the academic camp. "Rue Le Peletier is having a run of bad luck," wrote Albert Wolff in Le Figaro on 3 April 1876. "First there was the fire at the opera house, and now Fate has struck again. An exhibition of so-called art has just opened at Durand-Ruel's [...] Five or six lunatics blinded by ambition, one of them a woman, have put their work on show. These self-appointed artists call themselves rebels, Impressionists; they take a canvas, brush and paint, fling on the colours indiscriminately, and then sign the thing." Criticism such as this is not only of anecdotal interest; it is also revealing of the cult of the hatchet job that was prevalent in the arts pages at the time. Critics dipped their pens in acid, and were popular with the educated public if they were sarcastic and superior in passing their judgements. They affected to be defending the values of academic art, and of French art in particular; and in the process, often for the sake of a witty turn of phrase, they might ruin a painter's life. Their verdicts influenced not only the reputations of artists but also sales. Patrons and collectors might well be considered feeble-minded, or at least unable to see what was before their eyes, if the critics' opinion went against them - and this was the case with the market in Impressionist art for over twenty years.

One who chose to ignore the critics was Ernest Hoschedé. A departmentstore director and château owner, he began fairly early (and not without a speculator's ulterior motives) to collect the Impressionists on a large scale. In summer 1876 he commissioned Monet to paint decorative panels for a salon at his Montgeron residence. A brief year later, he was bankrupt, and when his collection was auctioned off a number of Monets were sold for extremely low prices. One was *Impression, Sun Rising* (p. 31), for which Hoschedé had paid 800 francs at the first Impressionist exhibition the year before; it now changed hands for a quarter of the price. For the Impressionists, the auction was a disaster. The prices their paintings fetched, which had been inching their way up, now hit rock bottom in a glare of publicity; and Monet, for one, felt he was having to start all over again. Nearing forty, he was no further than he had been ten years earlier. On 28 June 1875 he had written to Manet:

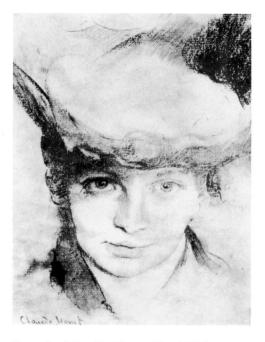

Portrait of Camille Monet (?), 1866/67 This red chalk drawing, one of the few drawings by Monet that have survived, is probably of Camille Doncieux – Monet's lover, wife, and mother of his two sons. But the sitter and date have not yet been definitely identified.

The Church at Vétheuil, Winter, 1879

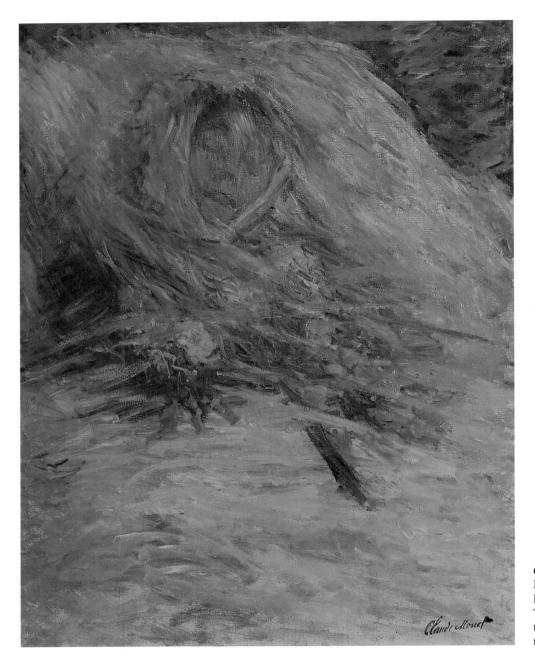

"Things are going worse and worse. Since the day before yesterday I have had not a sou, and no credit anywhere either – not at the butcher's, not at the baker's. Even if I have confidence in the future, the present remains very difficult [...] Could you possibly send me 20 francs by return? It would tide me over for the moment." He was to write countless begging letters in the second half of the 1870s; as well as this one, there were others to Durand-Ruel and other patrons and friends. Usually so proud and dynamic, Monet whined, abased himself and cursed his own work. Compelled by circumstances, he perfected the rhetoric of the begging letter, imploring the few collectors of his work to take whole batches of paintings at give-away prices. In summer 1878, after an intermezzo in Paris, Monet and his family (now including a second son, Michel, born in March) moved to a modest house at Vétheuil. The Hoschedés, now bankrupt, joined them with their six children.

The autumn sunshine revived Monet's spirits. "I have pitched my tent by the Seine at Vétheuil," he wrote to Murer on 1 September 1878, "in an en-

Camille Monet on her Deathbed, 1879 Monet painted his dead wife as the first sunlight of the new day was entering the room. This is no conventional deathbed picture done to record the features of the dearly loved, but the highly personal record of a dark hour.

Ice Floes at Vétheuil, 1880

After the hard winter of 1879/80, a sudden thaw transformed the river, sending ice floes crashing down the waters. The willows and

bushes along the banks are reaching like weary fingers into a sky that looks as if it will never brighten again.

Vétheuil in the Mist, 1879

The village is a mere hazy silhouette in this picture. Jean-Baptiste Faure, a celebrated baritone at the Paris opera and one of the first collectors of Impressionist art, bought it from Monet but quickly returned it, saying that although he himself liked it his friends never tired of poking fun at him for buying a painting with nothing on it. Monet kept the picture till he died, and would not have resold it for the world.

Paul Durand-Ruel, ten years Monet's elder, was the son of a Paris art dealer. Trained in his parents' establishment, he became the Impressionists' most influential dealer.

chanting area." From his studio boat he painted the banks of the river, and the little village with its Romanesque church. Money, though, remained in short supply, and Monet was in despair, writing to de Bellio on 30 December that year: "I am not a beginner any more, and it is dreadful to be in such a position at my age, forever begging and pestering buyers. As the year ends I am doubly aware of my misfortune, for '79 is beginning as this year has ended, in utter despondency, especially with regard to my dear ones, to whom I have not been able to give even the smallest present."

Monet's wife, apparently as a result of an unsuccessful abortion, had been weak for some time, and was in fact not to recover. Camille Doncieux, his only model, the lady in the green dress, the lady who walked the poppy fields and meadows, her summer dress billowing and parasol held high (p.24), his sunny muse and the very personification of all Impressionism stood for, died on 5 September 1879, aged only thirty-two. She left two young sons and a despairing husband at odds with himself and the world. "One day," Clemenceau recalled his friend Monet confiding, "I found myself at daybreak at the bedside of a dead woman who had been and always will be dear to me. My gaze was fixed on her tragic temples, and I caught myself observing the shades and nuances of colour Death brought to her countenance. Blues, yellows, greys, I don't know what. That is the state I was in. The wish came upon me, quite naturally, to record the image of her who was departing from us for ever. But before it occurred to me to draw those features I knew and loved so well, I was first and foremost devastated, organically, automatically, by the colours. Against my will, my reflexes took possession of me in an unconscious process, as the everyday course of my life took over. Like a draught animal working at the millstone. Pity me, my friend."

But Monet's picture of his wife on her deathbed (p.46) is more than a study in light. He had recorded Camille's features in one of his rare draw-

Durand-Ruel was the first dealer to take artists under contract for their entire output and to pay them an allowance to assure them a living. In a time of particular financial difficulty, Monet was commissioned to paint flower panels for the doors of Durand-Ruel's great salon at home.

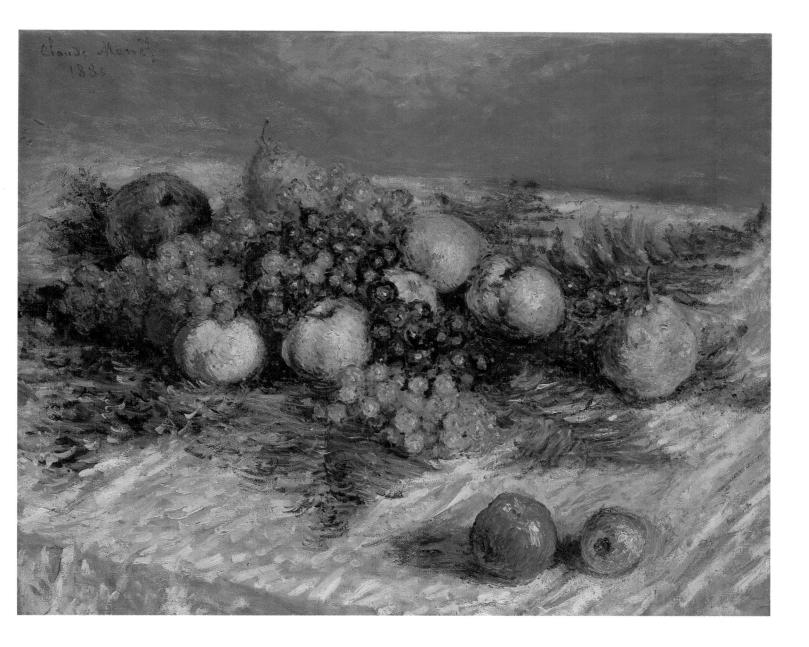

ings (p. 45). Her alert, serious eyes and her soft, expressive mouth suggest a person both tolerant and warm of heart. In the deathbed painting, though, there is no eloquence in her features: the dead woman's face is merely sketched in as she lies on the pillows, seeming to sink into depths of night and icy cold. Warm sunlight is lighting the bed from the side, and it is as if the artist hoped those first beams of morning sunlight might warm the cold and frozen face once more. But the sole answering glow comes from the handful of blossoms at her breast. Monet's brushwork in this painting is disturbed, angry, immoderate, torn, and at points movingly tender. The dichotomy between the coldness of death, on the one hand, and the warm sunlight of a day dawning for the living on the other, makes this so very personal painting a document of utter, devastating loss.

Monets paintings from the harsh winter that followed seem echoes of that experience. He had already painted snow, gleaming and lit by clear winter sunlight, casting luminous blue shadows, but also the dull, slushy browns of February, with farm folk stomping along muffled to the eyeballs, so vivid that we can almost feel how cold and wet their feet are. But the winter *Still Life with Pears and Grapes*, 1880 Only at one period in his career, around 1880, did Monet give any greater attention to still lifes. His fruit and flower pieces were widely admired, but he painted few of them.

The Customs Post at Varengeville, 1882

Monet went through in Vétheuil was different. Icy and grey, it was above all a deserted, solitary season. No birds are in these pictures, nor people either: only ice floes logjammed in the frozen river (p.47). The very sun seems cold. It is as if the landscape were pervaded by Monet's grief and desolation.

It was during this period that Monet began gradually to relax his ties with the other Impressionists. They accused him of no longer supporting the group and its activities, for his own ends. Monet was trying once again to ex-

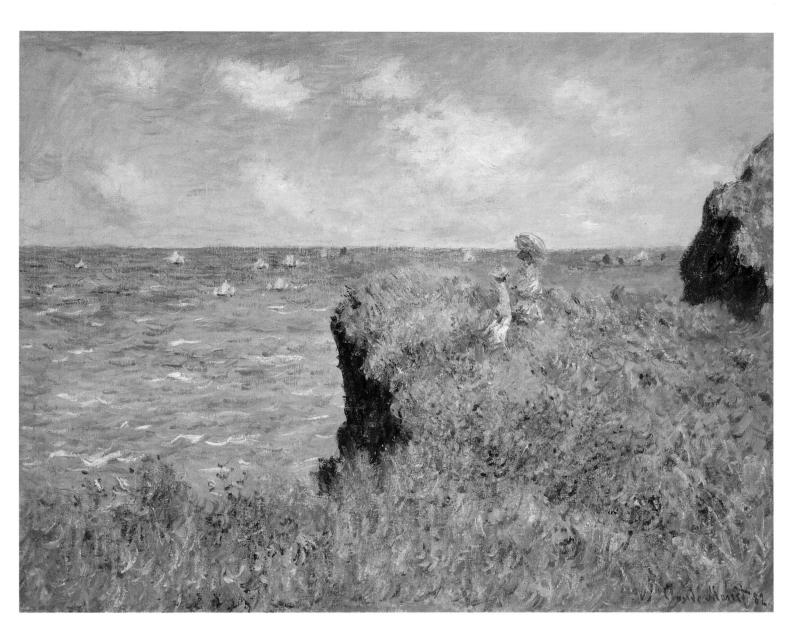

hibit at the Salon; and in fact the jury did accept one of his paintings, though it was hung in the topmost row. In the winter of 1881, Monet moved again, to the small town of Poissy, some twenty kilometres from Paris. It was not a particularly attractive area, and at first left Monet dissatisfied. He wrote to his dealer: "Poissy has yet to inspire me even remotely". Nevertheless, 1882 turned out to be a productive year. He visited the coast of Normandy a number of times, and painted *The Customs Post at Varengeville* (p. 50) from a number of angles and at various times of day. He also painted a little chapel high above the sea, and repeatedly took the sheer cliffs as his subject. The cliffs served him not only as a subject in themselves but also as a means of trying out unusual visual angles. These coastal paintings show Monet venturing towards series work for the first time.

"It is a real Monet," Rodin is said to have exclaimed when he saw the sea for the first time. Over the next few years, the river painter became a marine painter. Monet entered into lonely communion with his subject. Out in the icy cold, wrapped up in blankets and coats, the foam spraying about him, Monet studied the sea, moving closer and closer to his mighty subject. The *A Walk on the Cliffs at Pourville*, 1882 The cliffs of Normandy fascinated Monet, not only for the light and shadow, the flowers and grasses, but also because they made unusual lines of vision possible.

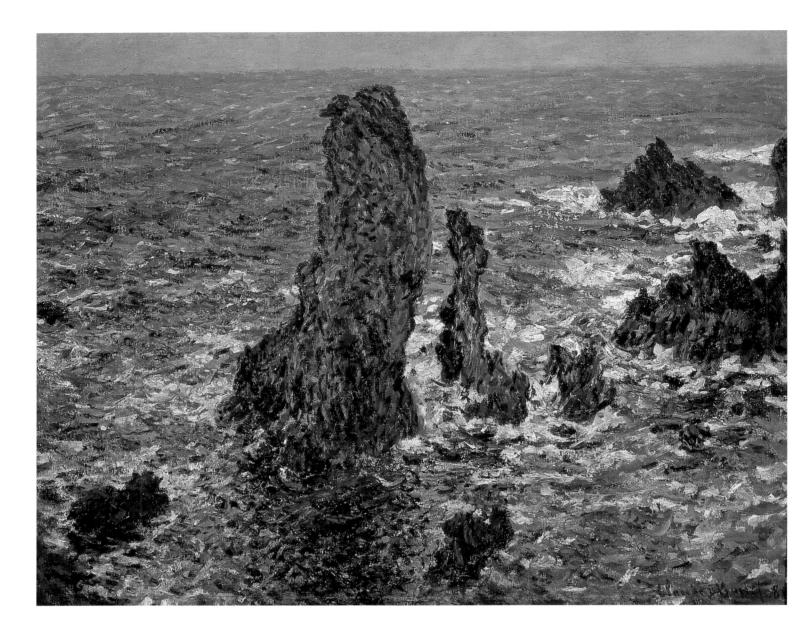

The "Pyramids" at Port-Coton, 1886 In winter 1886, Monet wrote from Brittany to Durand-Ruel: "The sea is unbelievably beautiful and there are the most outlandish rocks [...] I am filled with enthusiasm for this eerie area, because it forces me to go beyond what I usually do. I have to admit I find it very difficult to convey the foreboding, terrifying aspect of it." high cliff faces became surfaces on which light was projected, where light reflected from the water warred with direct sunlight. The Manneporte (cf. p. 53), a huge rock arch near Etretat, was seen powerfully confronting the vast waters of the ocean. Monet defied all kinds of weather in his pursuit of his subjects, and never gave up. As in his early days, struggling with his father or blasé critics or the prejudiced public, Monet throve on adversity.

At Etretat and Belle-Ile he took bare cliffs, choppy seas, and the constantly changing brightness and colours of the sky as his subjects, and tirelessly went in quest of the shifts in the light; people had well-nigh disappeared from his art. Strictly speaking, Monet (unlike Manet or Degas) was never a figure painter anyway. In early works, the light that fell upon a woman through a parasol interested him more than the woman herself, and when later he placed figures in his paintings it was because they created a sense of spatial scope in his landscapes. He valued people for the rhythm and dynamics they introduced into his pictures, but disregarded their personal histories. When he painted two full-lengths of Suzanne Hoschedé in the 1880s, turning to a human figure in the open as he had done at the outset

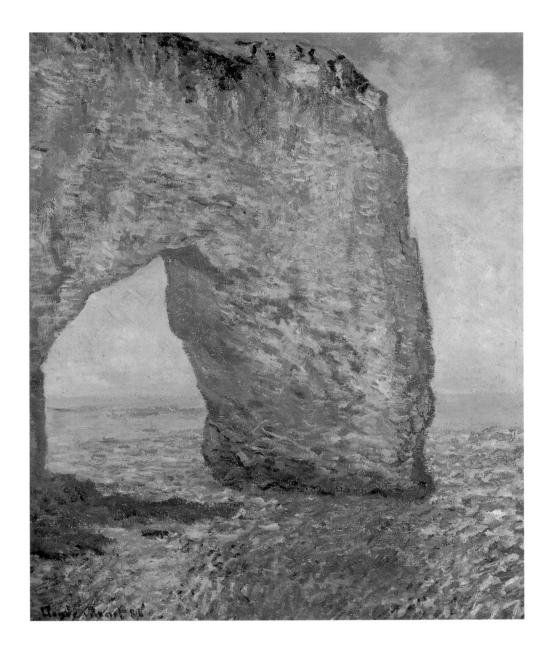

```
The Manneporte at Etretat, 1886
```

of his career, the results were not so much freshly-conceived artworks as dreamy reminiscences of old, happy days at Argenteuil (p. 56).

Monet had fled from Vétheuil, and had never really settled in Poissy; and in 1883 he rented a house at Giverny and moved there with a large family that included his two sons, Alice Hoschedé (Ernest's wife), and her six children. Moving their possessions across the Seine by boat was quickly accomplished and a more peaceful, happy time began in their spacious and simple country home. It was the last time Monet moved. The second half of his life was spent at Giverny, and there he found the calm and strength to complete his work.

In the early 1880s, the market in Impressionist art revived. Durand-Ruel was energetically representing their interests once again, and Monet's solo exhibition in his gallery in spring 1883, though disappointingly few sales resulted, earned favourable reviews. A few years later, Durand-Ruel was to open a gallery in New York and score great success with Monet's views of Belle-Ile and the paintings that resulted from his sojourns on the Riviera and the Côte d'Azur.

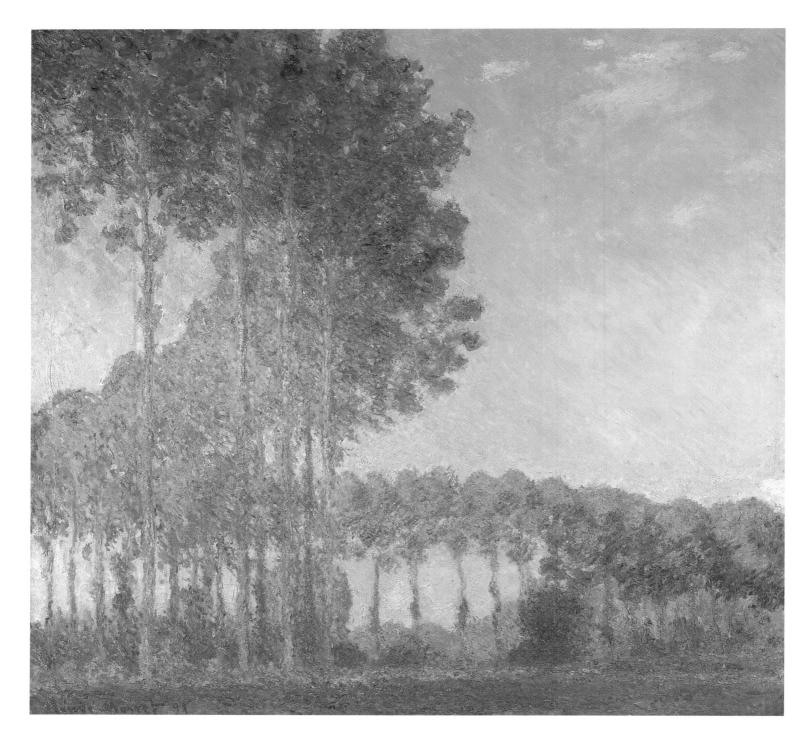

Poplars on the Banks of the Epte, 1891

Concentration and Repetition: Working in Series

At times Monet imagined what it would have been like to be born blind and then suddenly be able to see, and to paint, without knowing what the thing one saw actually was. He felt that one's first clear look at a subject was the most honest, because least sullied by preconceptions and prejudices. His interest in this thoroughly genuine way of seeing led Monet to an in-depth study of atmospheric effects. To him, a subject was not what it was but what the light made of it. It was in this spirit that he had already, at an earlier point in his life as an artist, painted various views of one and the same subject, in various moods. Thus, for instance, he had painted the bridges at Argenteuil in bright sunlight or in rain, in broad inclusive views or in detailed close-up. He painted Vétheuil, with its little Romanesque church, from the same position in fog and beneath the blue skies of summer. As the years went by, his studies in atmosphere became more and more systematic, his investigations veritably scientific in their thoroughness. From Impressionist studies he evolved whole series showing haystacks, poplars, and finally the west front of Rouen Cathedral. And finally, in the Nymphéas (or waterlilies), he was to apply his principle to the very end.

In 1890 and 1891, Monet worked on a series of paintings of haystacks (pp. 58 and 59), a subject that would have struck contemporary taste as not merely simple but downright unimaginative. In some he painted them close to; in others he painted two stacks instead of one; but always the compact, snug shape of the haystacks remained central. His treatment presented them in very different ways, vibrant in the ruddy glow of the setting sun, mutely massive in the snow.

At about the same time, Monet painted poplar trees along the banks of the Epte (pp. 54 and 55), again working on his subject at various times of day and seasons of the year. Where the haystacks had offered compact, solid shapes, though, the poplars tended to produce linear compositions. In a manner comparable to his work on bridges and railway stations, Monet wrought the skyward verticals of the trees, the horizontal of the riverbank, and the further verticals of the tree reflections in the water, into a grid-like pattern of lines. Upon this grid are superimposed the atmospherics of (say) autumn sunlight breaking through morning mist. In some of the series, the glaring light of a hot summer day, shining off the leaves, transforms the whole into a fabric of shimmering impressions.

It was not the first time that artists had painted variations on the same theme. What made Monet's work more specifically a *series*, though, was the attempt to follow the selfsame visual motif through the most various of

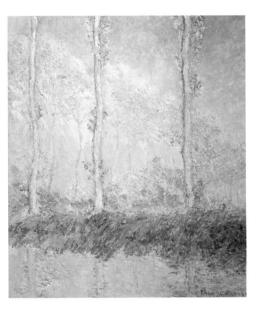

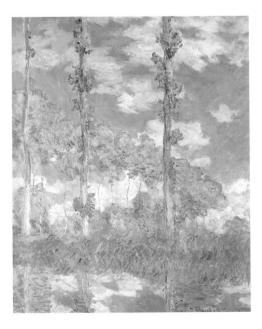

TOP: Poplars, Three Pink Trees in Autumn, 1891

BOTTOM: *Three Poplars in Summer*, 1891

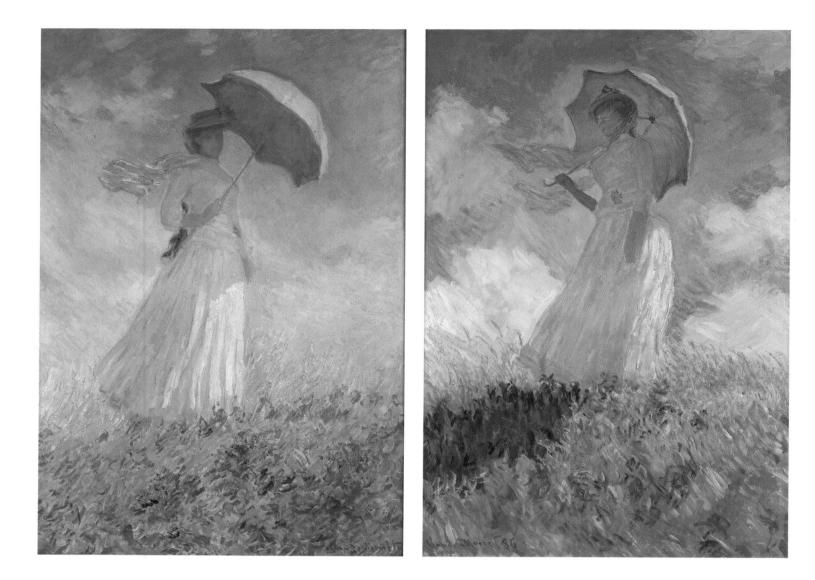

LEFT:

Open Air Study, Woman Facing Right, 1886 RIGHT:

Open Air Study, Woman Facing Left, 1886 Not Camille, but Suzanne Hoschedé now, Monet's stepdaughter, modelling for him out of doors. This pair of pictures (not a series) were Monet's last venture into lifesize fullfigure portrayal in the open. states. His most consistent experiment in this line was the series of views of Rouen Cathedral (pp.60 and 61), painted from 1892 to 1894. The mighty late Gothic edifice, its history dating back to the 12th century, its west front richly adorned with tracery and opulent figure work, was one of the great achievements of the Middle Ages in France. In February 1892 Monet rented a small room opposite the west front for the first time, and that year and the next, as winter faded into spring, he painted the cathedral from three only minimally varying positions. Probably all thirty paintings of the façade would have been identical in their angle if Monet had been able to keep the room he first rented.

Never before had a painter viewed his subject so close to. The canvas space is not merely filled by the sectional view of the west door and towers; the picture *is* the façade. Monet observed the passing effects of light on the façade, from an early hour when the morning mist had yet to lift till the last rays of the setting sun. In some of the paintings, the cathedral is mysteriously shrouded. In others it is warm with morning light. And in yet others the last of the evening sun is setting gleams and highlights across the filigree of the majestic front.

Two years running, from early February to late April, Monet painted *sur le motif*, recording the cathedral in varying conditions of light; and he re-

ported that some of the lights and atmospheres he observed lasted for only a few minutes. On 30 March 1893 he wrote to Durand-Ruel: "I am working as hard as I possibly can, and do not even dream of doing anything except the cathedral. It is an immense task." In the third year, Monet reworked the cathedral views in his studio, working on the different moods simultaneously and refusing to let any one of the pictures out of his hands until all of them were finished. The continual reworking resulted in pastose paintwork so richly textured that some who saw it compared it to mortar. Though fleeting shifts of light doubtless prompted each one of the pictures, the studio reworking played as germane a part in creating the finished images as the impressions gained on the spot. Harmonies are established by the contrasts between individual paintings often conceived in terms of a very few, complementary colours. The filigree façade became a pretext for patterned composition of a rhythmic type.

In his earlier studies of light at Argenteuil and Vétheuil, Monet had tried to make his eye a neutral monitor of the visual world, recording impressions in quasi-photographic manner. Much the same has been claimed where his series of the 1890s are concerned; but here, in fact, the artist is quite deliberately introducing into the pictures his own subjective response to what he has seen. The effects of colour he presents are analogous to what he has seen, rather than an exact record. And Monet's free technique matches his imaginative approach to colour. Even though his subjective experience of a fleeting moment provides the basis for each of Monet's canvases, the final reworked versions go beyond a record of passing phenomena. The motif is shorn not only of all detail but also of its material, textural qualities. Stripped of anecdotal elaboration or contextual placing, the paintings seem to stand monumentally above and beyond Time.

Monet's dogged pursuit of the series principle coincided with a growing demand for his work; in consequence, he was inevitably reproached by artist friends with painting series simply in order to satisfy that demand. And it was certainly true that the series paintings were well received. When the *Haystacks* were exhibited in 1891, for instance, every one of the paintings was sold within days. Monet, however, was highly critical of himself and his work, and more than once destroyed entire series of paintings. Furthermore, the various paintings within a series are so palpably the product of an intense study of conditions and changes that accusations of opportunist series production are clearly beside the point.

At long last, after years in reduced circumstances, after the endless humiliation of begging for paltry sums to cover the necessities of life, Monet was enjoying success. He was now recognised, and soon regarded as one of the most important painters of the times. The cathedral series was not only a major achievement in the creative work of a mature painter, but also clinched Monet's breakthrough. An exhibition of twenty of the approximately thirty Rouen Cathedral pictures, at Durand-Ruel's in May 1895, was a great success. Monet's friend, the politician and subsequent prime minister Georges Clemenceau, pressed for the state to purchase the paintings; official, institutional distrust of the erstwhile rebel Monet was too great, though, for the purchase to come off. The series – conceived, painted and exhibited by the artist as a single set – was dispersed.

Rouen Cathedral, c. 1900

Haystacks, c. 1888/89 "For me, the subject is of secondary importance: I want to convey what is alive between me and the subject."

Claude Monet

ILLUSTRATION PAGE 58, TOP: *Haystack, Snow, Overcast Sky*, 1891

ILLUSTRATION PAGE 58, BOTTOM: Haystack in the Snow, Morning, 1891

ILLUSTRATION PAGE 59, TOP: *Haystack in Sunshine*, 1891

ILLUSTRATION PAGE 59, BOTTOM: *Haystacks in a Thaw at Sunset*, 1891

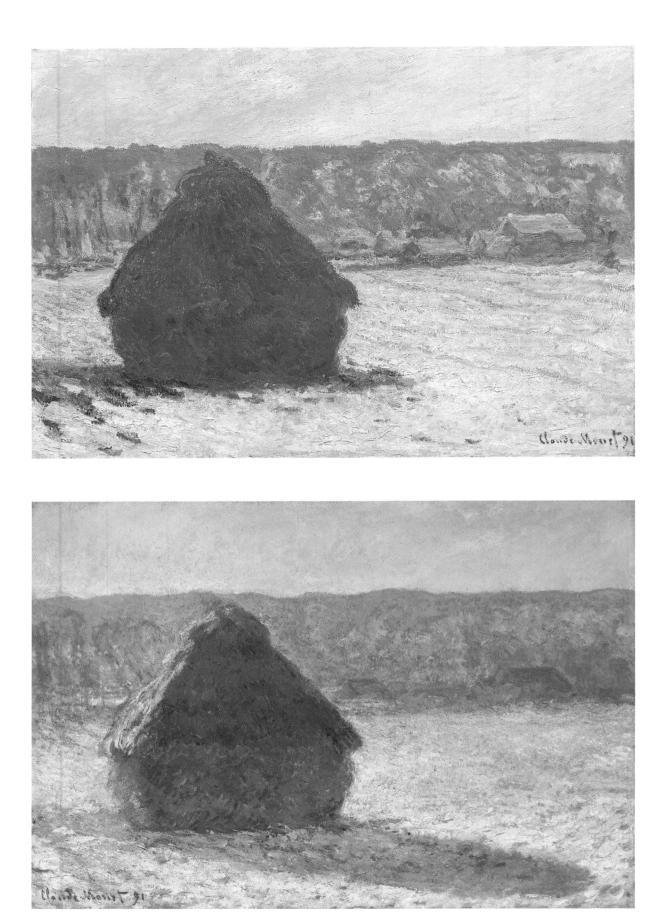

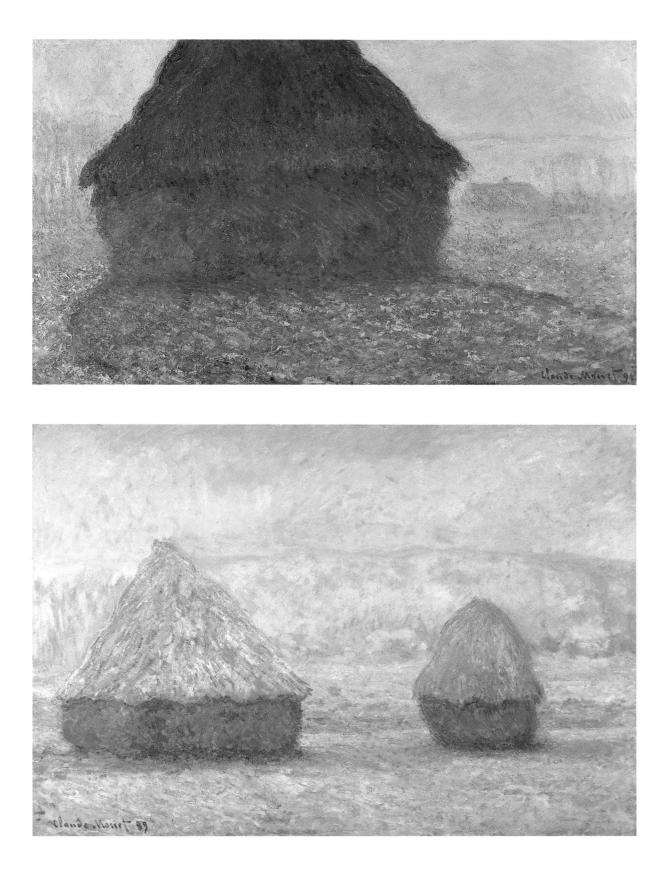

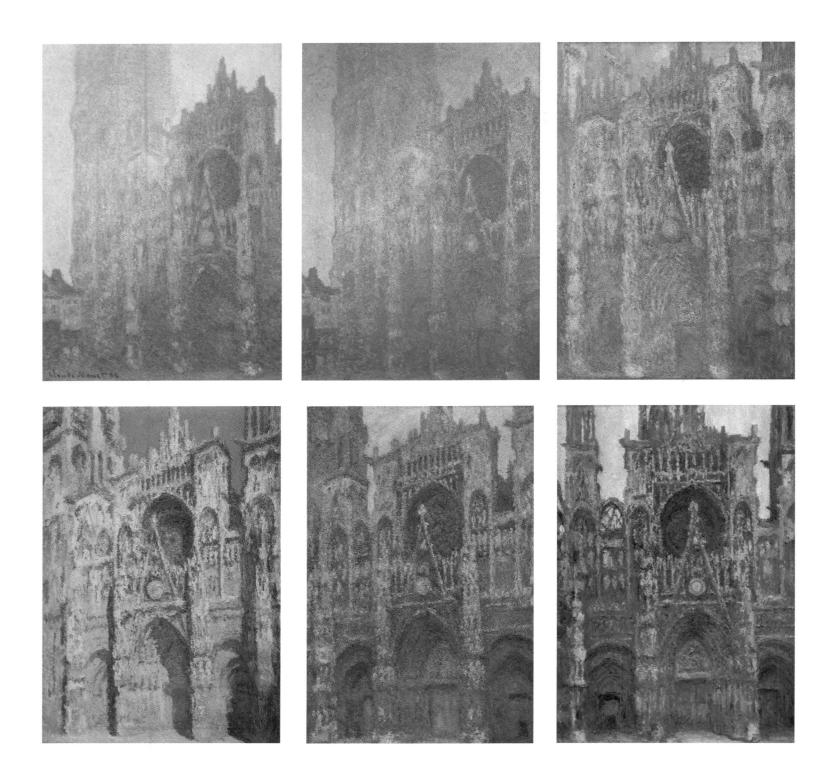

TOP LEFT:

Rouen Cathedral in the Morning. The main entrance and the Saint-Romain Tower, 1894

TOP CENTRE:

Rouen Cathedral. The main entrance in morning sun. Harmony in blue, 1894

TOP RIGHT:

Rouen Cathedral. The main entrance and the Saint-Romain Tower in the morning. Harmony in white, 1894

BOTTOM LEFT:

Rouen Cathedral. The main entrance and the Saint-Romain Tower in bright sunlight. Harmony in blue and gold, 1894

BOTTOM CENTRE:

Rouen Cathedral. The main entrance and Saint-Romain Tower on a dull day. Harmony in grey, 1894

BOTTOM RIGHT:

Rouen Cathedral. The main entrance. Harmony in brown, 1894 ILLUSTRATION PAGE 61: see p. 60, top left

Many 20th-century artists have painted series, and it is tempting to see Monet as the precursor of them all. Unlike later artists, who used the series principle as a way of progressing conceptually to greater experimental abstraction, Monet always took Nature as his point of departure.

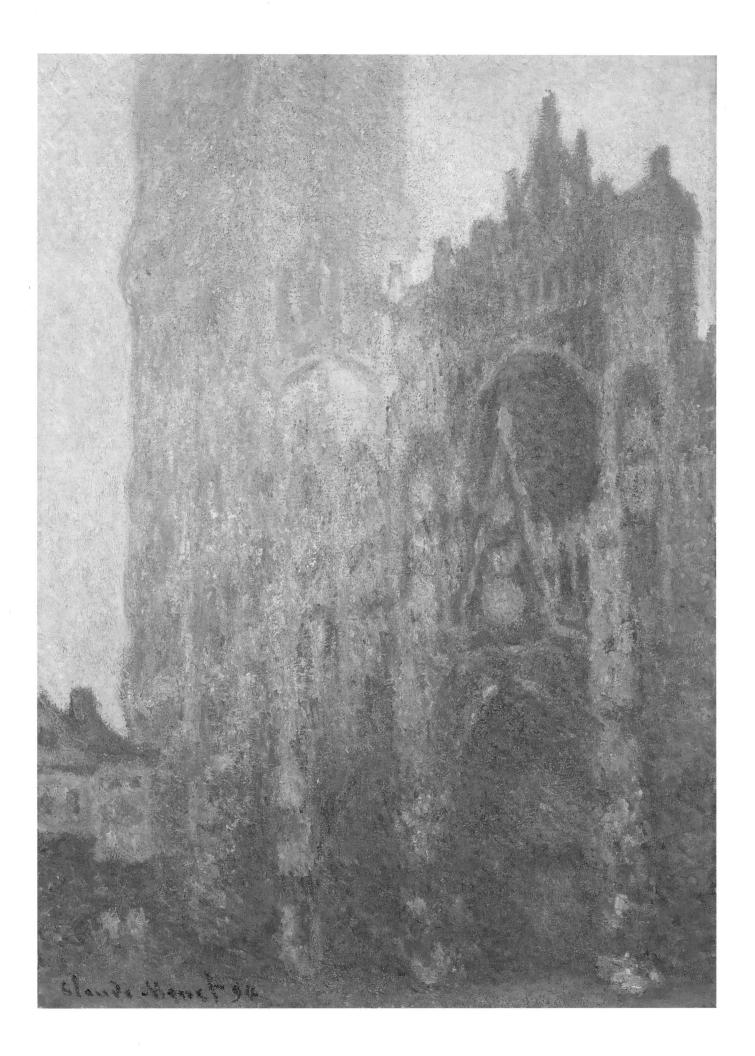

Different Countries and Different Light

Northern France, with the craggy cliffs and green pastures of Normandy and the coast of Brittany, was Monet's original home, and he revisited the region countless times with his palette and easel. But he was also drawn to unfamiliar parts where the landscape and vegetation were new to him. In quest of a different light, he travelled to other countries. The pines and palms of the Riviera and the winter gleam of the Côte fleurie; the tranquil calm of snowy days in Norway; the resplendent tulip fields of Holland; London in the fog; and the iridescence of Venice – all of them captivated him. Even more alert and responsive (if that were possible) than on his home ground, Monet absorbed new moods and subjects, pouring his enthusiasm into letters home.

Soon after moving to Giverny, Monet travelled to the south of France with Renoir, in December 1883. He did not take his sketch pad, lead pencil and watercolours with him, as so many artists before and after did as they embarked on their apprentice and journeyman years. Rather, he took his easel, palette and a few dozen canvases, and a hefty suitcase full of warm woollens. The journey must have been a laborious business in consequence, and Monet will have attracted a fair amount of comment from fellow travellers. Renoir later described one such trip to his son. First-class passengers did their best to look bored or preoccupied, and a painter taking his seat among them with his umbrella and paintbox must have seemed "like a coalman who has accidentally wandered into a fashion show"; but in second class it was even more unpleasant, "for the affectation of the passengers was all the worse because they could not afford to travel first class". The only passengers Renoir described as pleasant and even generous company were those in third class, which the two artists at first used of necessity and then because they felt uncomfortable in the other two classes. Some passengers were provisioned as if for a trip around the world, and, as the kilometres sped by, so their meals were produced – and shared with the lean and hungry painters, who fed on "Burgundy cheesecake or provençale pot roast [...], young Côte d'Or wines or fruity rosés from the banks of the Rhône". As the artists travelled they would be regaled with observations on the crops or taxes, tales of family troubles - or the ordeals of corset-wearing. "After a mouthful or so, one ample farm woman could not stand it any longer, and, begging our pardon, undid her underthings and asked the woman beside her to unlace the back of her corset. Her liberated flesh could now spread as it wished, and the pâté of hare finally tasted as good as it ought."

Back home, it was only a few weeks till Monet departed for the south again, though this time without Renoir: "I have always worked best on my

Bordighera, 1884

ILLUSTRATION PAGE 62, TOP: *Villas at Bordighera*, 1884

ILLUSTRATION PAGE 62, BOTTOM: **Palm Trees at Bordighera**, 1884 Exotic plant life with snow-covered mountains in the background, the clear air and the blue water, all intoxicated Monet on his first winter visit to the Mediterranean: "The palms will make me despair [...] So much blue in the sea and the sky – it is impossible!" (To Alice Hoschedé, January 1884.)

View of Menton from Cap Martin, 1884 "I hired a good carriage and had myself driven to Menton, a delightful outing of several hours. Menton is wonderful and is in a splendid setting. I walked to Cap Martin, a famous spot between Menton and Monte Carlo. I saw two motifs there that I want to paint because they are so different from things here, where the sea plays no big part in my studies." (To Alice Hoschedé, February 1884.)

> own, following my own impressions," he wrote to Durand-Ruel on 12 January 1884. He returned to Bordighera, a coastal village between Monte Carlo and San Remo that he had discovered on his first trip, and painted the sea, sky, and pine trees contorted into arabesques, like mysterious living creatures dancing in the bright sun. For his pictures of lemon groves, olive trees and palms, Monet increasingly used colours almost new to his palette, such as turquoise and ultramarine, pink and a mandarin shade of orange. The palms grew in the walled garden of a Monsieur Moreno, and were considered the finest on the coast.

> "This is fairytale country," Monet wrote to Theodore Duret on 2 February. "I do not know where to look first. It is all extraordinarily beautiful and I want to paint everything [...] This landscape is entirely new to me, something to be studied, and I am only just beginning to be familiar with it; and to know where I should go and what I can do is terribly difficult – one would need diamonds and precious stones in one's palette." Monet returned home having started on fifty canvases – though hardly one of the paintings was completed.

> Five years later he again visited the Mediterranean. In January 1888 he stayed on the Côte d'Azur, painting the sea against the backdrop of the snow-covered Esterel Mountains (p. 65, bottom). A pine marks a bold diagonal across the landscape horizontals, lending a scene almost non-spatial in its muted winter colours a striking foreground that not only defines distance and size but also introduces tension into a placid composition based on horizontals. Unusually composed, the picture was again inspired by Japanese woodcuts.

From the promontory of Cap d'Antibes, Monet painted the fortified town of Antibes (p.65, top), trying to capture on canvas the intensity of winter light by the Mediterranean. The bright radiance is conveyed by strong contrasts of cold and warm, an entire range of glowing creams, pinks and vermil-

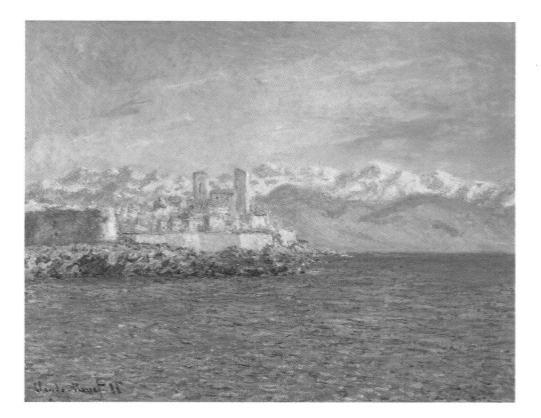

Antibes in the Afternoon Light, 1888

ions being juxtaposed with cold blues and greens on a ground of pale blue, and especially large quantities of white being admixed. "It is so beautiful here, so bright, so full of light!" Monet wrote to Gustave Geffroy on 12 February 1888. "One is afloat in blue air. It is awe-inspiring."

The south coast pictures were tremendously successful. "I have just left the exhibition, delighted by the work you did last winter," the poet Stéphane Mallarmé wrote to Monet on seeing the Antibes paintings. "For a long time I have ranked what you do above all else, but I believe you are now at the

height of your powers." Monet, though, was dissatisfied. He was afire for a world of gold and precious stones – and in despair to see that what his brush recorded on the canvas was merely pink and sky blue. Time and again he wrote of his vain attempts to convey the Mediterranean atmosphere, only to be disappointed by the picture he in fact painted. The continuing cultivation of his paradisean garden at Giverny notwithstanding, he was restless. Perhaps what he sought away from home was not only new impressions but also creative solitude and a respite from his ever-growing family, which included increasing numbers of sons- and daughters-in-law and was soon to include his first grandchildren too.

Monet took to travel. He visited his stepson in Norway, went to the south of France on several occasions, and, after the turn of the century, even undertook motoring tours, to Madrid and to Venice. London too – where the iridescent atmosphere and the countless, constantly changing shades of grey had fascinated him back in 1870 – attracted the artist on several occasions. Around 1900, from the balcony of his room at the Savoy Hotel and a window of St Thomas's Hospital, he painted his Thames series, including works

Mount Kolsaas with Pink Reflections, 1895 Monet returned from an 1895 visit to his stepson in Norway with only a handful of pictures. Mount Kolsaas, heavily snow-clad, became an object of mystery and meditation in Monet's picture.

such as *The Houses of Parliament in London* (p.67) and *Waterloo Bridge in the Mist.* Again Monet worked with a multitude of canvases, turning to the one or the other at various times according to whether his subject was shrouded in fog or the sun was breaking through. To Durand-Ruel he wrote on 23 March 1903: "I cannot let you have a single London picture, since it is essential that I have them all before me, and, to be honest, not one of them is finished. I am working on them all together." Nor were the paintings completed by the time he returned to Giverny, and over the next few years he continued to work on them in his studio. Comparison of *The Houses of Parliament in London* with *Impression, Sun Rising* (p.31), painted thirty years earlier, shows clearly how Monet's art had changed. In both paintings there is a similarity of subject matter; indeed, there are several London canvases in which Monet has placed small vessels in the foreground water, like those in the *Impression*. But the way in which the subject is seen is fundamentally dif-

Monet and Theodore Butler in the car

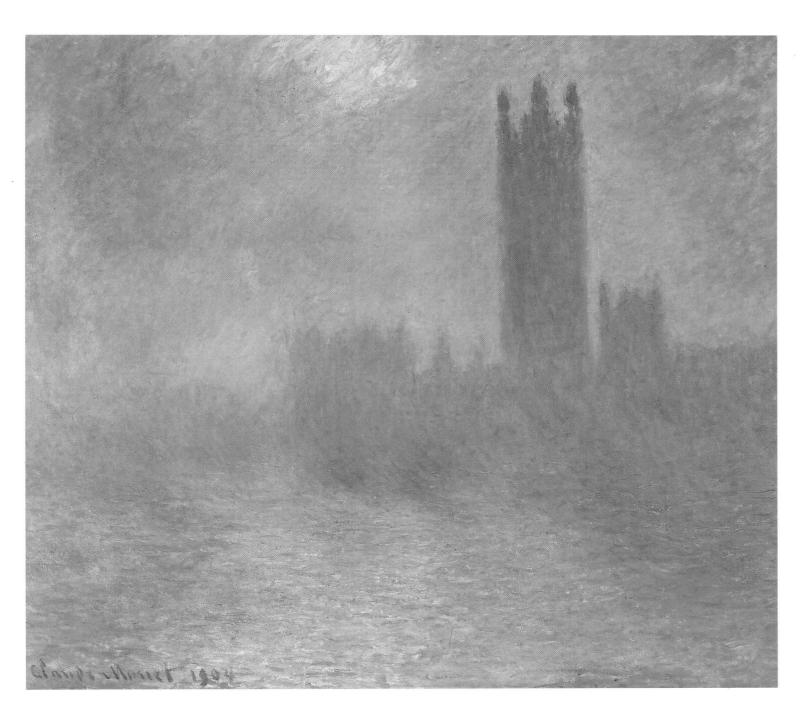

ferent. The Thames scenes no longer have the sketchiness of the *Impression*; instead, they have a meticulously achieved, monumental sense of completion. The atmospherics and light at particular moments may well have provided points of departure for the individual pictures, but Monet worked his impressions into abstract complexes of colour. His architectural subjects no longer established graphic spatial structures like ships and bridges in earlier paintings, but demarcated a handful of larger zones in which to explore colour. Monet's water, sky and buildings became areas on which to project shimmers of colour, no more tangible than the hazy air itself. The Victorian Gothic of the new Houses of Parliament are eerily insubstantial in the mist. Both the subject and the overall scene are painted in abbreviated brush-strokes, and he has used every colour of the spectrum.

When Monet visited Venice in 1908 he again created sublime tapestries of colour of this order, of an abstraction that no longer much resembled the in-

The Houses of Parliament, London, 1899–1901

For years, Monet continued to work on Thames scenes, with the Houses of Parliament or Waterloo Bridge, in his studio. The buildings rise enigmatically from their shrouds of shimmering fog, pierced by only a little sunlight.

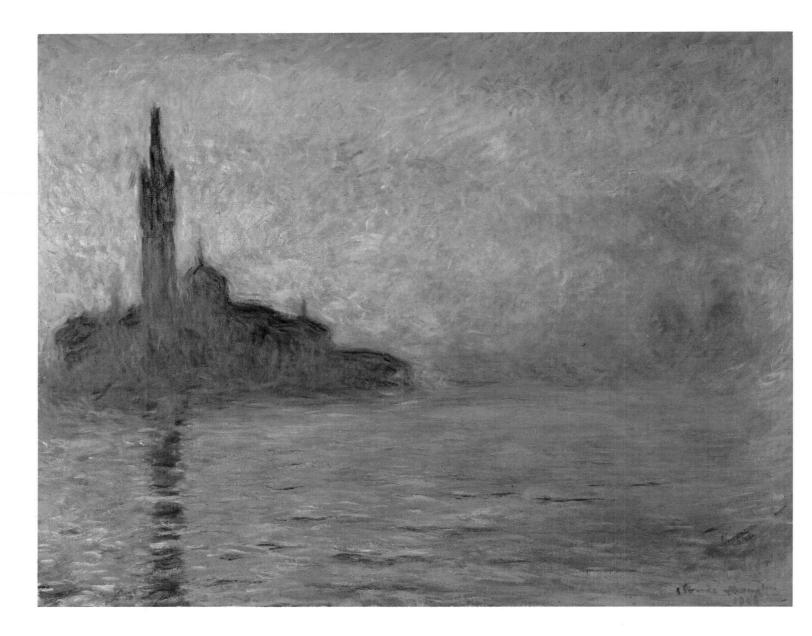

Evening in Venice, 1908

"It is so beautiful," Monet wrote from Venice of Palladio's Church of San Giorgio Maggiore, which he painted in a glory of setting sun. "I console myself with the thought that I shall return next year, for I have only been able to make a start. But what a pity that I did not come here when I was younger and more adventurous!" (Letter to Gustave Geffroy, December 1908.) stantaneous art of the great *Impression*. At the invitation of the Anglo-American artist John Singer Sargent, Monet and Alice Hoschedé (now married) spent two weeks in the Renaissance Palazzo Barbaro beside the Grand Canal. The first few days sped by, and Monet was so busy exploring the lanes and alleys and canals, absorbing the atmosphere, that he deferred his work. In the churches and museums he studied works by the great Venetian artists Titian, Giorgione and Veronese, with whose paintings his own had frequently been compared. The city's unique atmosphere, he felt, was beyond the power of art to capture. Yet presently there he was, with his palette and easel, beside the Grand Canal or the Doge's Palace, painting like one possessed and observing a strict schedule, rising at six and giving himself two hours on each motif. Not till the sun went down did he permit himself a break. His wife, somewhat concerned, wrote to Germaine Salerou (3 December 1908): "It is high time he relaxed. He is working very hard, especially for a man of his age."

Critics of the Venice paintings tend to speak of a faerie realm of colour; and it is true that the views of San Giorgio Maggiore or the Palazzo Contarini (pp. 68 and 69) share the mood of a Romantic fairy tale or a Symbolist

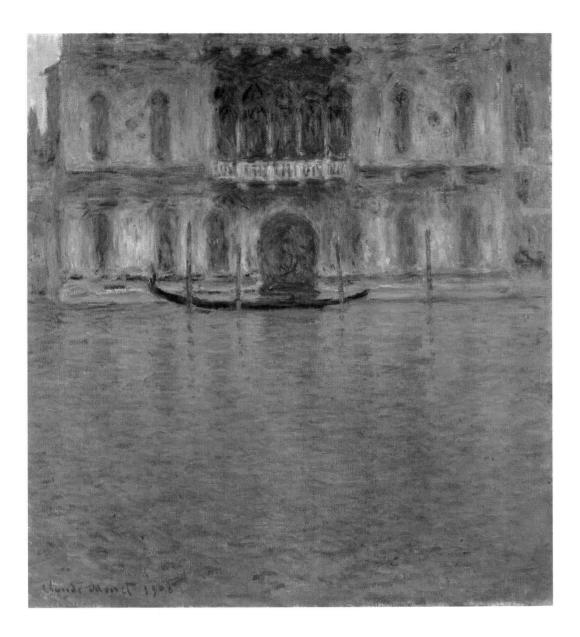

Palazzo Contarini, 1908

Monet and his wife Alice in St. Mark's Square, Venice, 1908

poem. As in the case of London's misty winter, the light of Venice need not necessarily have been as luminous, intense and glittering as it appears on Monet's canvases. When he was on his travels he would begin a great many paintings and subsequently complete them over the years in his studio or even begin afresh. The process of reworking would superimpose a multilayered fabric of shimmering colours on the entire surface, and would also, inevitably, strip the pictures of their immediacy and sketch quality, transforming them into finely tuned fantasias in paint. Monet's Venice works are compositions of veiled blue haze and mother-of-pearl reflections. They consist of recollections and visions rather than of visual experience registered *sur le motif.* A tendency already apparent in the haystacks, poplars and Rouen Cathedral series was confirmed in the pictures Monet painted from these travels in later life: the Impressionist had become a Symbolist, celebrating the mystical union of mist and architecture, of the material and the atmospheric, of stone and light.

The Garden at Giverny

In August 1901, *Le Figaro*'s art critic Arsène Alexandre recorded his first impression of Giverny, where Monet spent the second half of his life. "And then at last, Giverny appears at the end of the road," wrote Alexandre. "It is a pretty village, albeit somewhat lacking in character: half rural, half a small town. But suddenly, just as one comes to the end of the village and is continuing towards Vernon, without having felt any strong urge to stop, a new and extraordinary sight greets one, as unexpected as any big surprise. Imagine all the colours of a palette, all the notes of a fanfare: that is Monet's garden!"

Monet's regular sales since the mid–1880s had secured his financial position, so that in 1890 he was even in a position to buy the house. He now turned to the plot of land (which he extended over the years through a number of purchases) and, with great energy and devotion, succeeded not only in creating a home for his family but also in establishing his own earthly paradise – the garden at Giverny.

Not that the beginning was straightforward. The couple, still unmarried when they moved there with their eight children, no doubt challenged the conventional views of a farming community. This fellow Monet, who was supposed to be a modern painter, would stride off across the meadows at dawn, followed by an entourage of children carting his paint and canvases on a wheelbarrow, and set up in front of trees and haystacks, which he then set down in higgledy-piggledy brushwork on canvases he was forever exchanging. The locals soon found a way of turning this oddball to their own advantage, and charged him a toll whenever he crossed their fields on his way to paint. They would also dismantle haystacks or fell poplars once he was busy painting them, and Monet had many a struggle to keep his motifs as he wanted them. At a later date, when he was planning to create a pond with exotic plants in his garden, the villagers protested that the plants might damage their laundry (which they washed in the river) or poison livestock grazing below the garden.

Despite the difficulties, Monet and his family succeeded in transforming a Norman apple orchard into a garden that made history. Monet later said that he had simply leafed through a gardening catalogue and placed his orders, but this was doubtless one of his many understatements. In fact he put immense knowledge and patient toil into the creation of the garden, which became a veritable Eden of bloom and fertility. Arsène Alexandre described it thus: "Wherever one turns, at one's feet or head or at chest height there are pools, chains of flowers, blossoming hedges at once wild and cultivated,

Monet with his stepdaughter Blanche, who ran the household after the death of her husband and accompanied Monet when he painted. One of his many grandchildren is in the foreground.

The Japanese Bridge, 1899

changing with the seasons, ever becoming new." Quite clearly a power governed and shaped the garden, a power such as Monet displayed in his paintings, too. He assigned every plant its place, planning and ordering, laying out parallel borders according to varieties and colours. He was establishing his sovereignty over Nature. With subjects for paintings already in mind, he chose his plants, composing his works not only by choosing a position but also, from the very outset, by determining the appearance of the natural world. Early one year, when a mighty oak he was painting began to bud, Monet, rather than alter his painting, recruited village youngsters to climb

Spring, 1886

up and see to it that when he resumed work the next day there was not a trace of green to be seen. "One admires the painter, and feels sorry for the unhappy tree", observed the English painter Wynford Dewhurst, from whom we have the anecdote.

Quite unlike Emil Nolde, who created a down-to-earth farm garden at Seebüll, Monet had an unmistakable taste for the unusual and exotic in his Giverny garden. Of course he planted dahlias and nasturtiums too; but as the years went by the garden became more and more a place of pale blue wistaria and purple irises, tuberoses from Mexico, waterlilies gleaming like mother-of-pearl, tufty clumps of bamboo. Many of these plants, some of them imported from overseas, had only been grown in France for a short time; the local farming people's suspicion of the artist's unknown vegetation is therefore scarcely surprising. But it was not long before sophisticated circles in Paris and abroad began to take a keen interest in the garden. The first articles about it were published, and long after Monet's death (indeed, to this day) magazines and books gladly devoted their pages to the beauties of the Giverny garden, which still delights the many who visit it.

The garden became a part of Monet, and he of it; it entered into his soul and (most important for him) his eye. Wherever he travelled, he always asked after his flowers in letters home. The garden on sunny days was very life to him, and when it rained he withdrew to bed, depressed.

Not that Monet was a painter of flowers. In the early *Garden at Sainte-Adresse* (p. 20), it is clear that he was unconcerned to identify individual species or varieties, and later – though tea roses, poppies, and then water-lilies and wistaria, are all identifiable – Monet was never an artist meticulous in his botanical detail. What he was after was the harmony of the whole, the overall impression. For Monet, flowers were bearers of light, and a feast for the eyes.

The house at Giverny was spacious, though compared with the ornate opulence common at the turn of the century it was simple in style. The building itself, essentially of a functional kind, was soon mantled in ivy and climbing roses. After the death of Ernest Hoschedé, who had never recovered following his bankruptcy, Monet and Alice Hoschedé had married **Poppy Field in a Valley near Giverny**, 1885 At Giverny, Monet returned to the motif of the poppy field in flower (cf. p. 39). But in contrast to the bright, cheerful landscape that seemed casually noticed, the later picture is a symmetrical and almost austere composition based on the complementary colours of green and red.

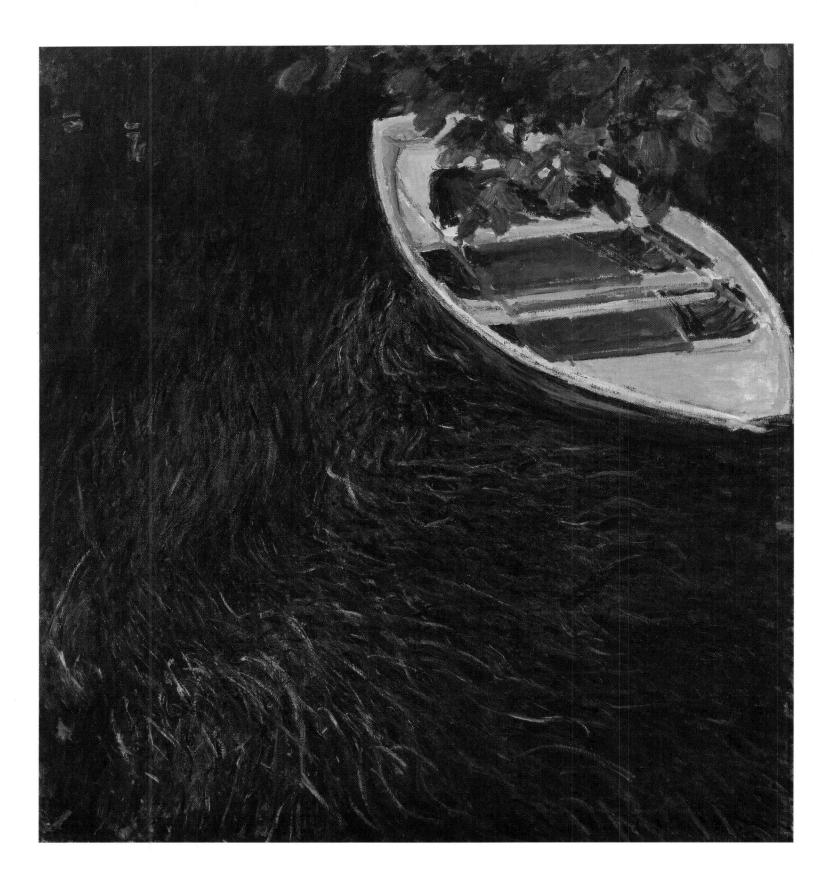

The Barque, 1887 The whole family enjoyed boating trips to the Ile aux Orties (Nettle Island). It lay near the bank of the Seine and could be reached down a channel that ran to Monet's property. Later he bought the island.

Girls in a Boat, 1887

Monet in his garden at Giverny, c. 1917

Monet's house and garden at Giverny, c. 1917

in 1892, placing the seal of legitimacy on a long-lasting relationship which may well have dated from old days at Montgeron, when Camille was indeed still alive. The fact that Alice had never been merely a housekeeper and nanny must presumably have been apparent to their friends and neighbours anyway.

Politicians and diplomats paid calls at Giverny, arriving by rail, crossing the Seine by boat, travelling in horse-drawn carriages, or, presently, driving up in rattling newfangled stinking automobiles. American collectors and Japanese aristocrats visited Monet, and so too, of course, did his old friends Renoir, Cézanne, Pissarro, his first biographer Gustave Geffroy, and above all Clemenceau, who served as prime minister from 1906 to 1909 and again from 1917 to 1920. Despite this high political friendship, though, Monet kept his distance from honours conferred by the state, declining the Cross of the Legion of Honour in 1888 and in 1920 refusing to enter the Institut de France.

Hard on the heels of his friends and collectors came the admirers of Monet. As early as the late 1880s, a colony of American artists, known as the "Givernists", was established. Monet chose never to teach, and contented himself with urging the young artists to use their eyes and study Nature; he soon felt that fame was making too many and too noisy demands of him, and among the young Americans who came calling every day he acquired a reputation for being "extremely ill-tempered". If he himself preferred to withdraw, though, his stepdaughter Suzanne married one of the ambitious American artists, Theodore Butler, in 1892. Over the years, the house, which was already a bustling place, opened its doors to further sonsand daughters-in-law and grandchildren, till family celebrations (as photographs show) began to look like village carnivals. Monet, already the bon bourgeois in his Argenteuil days, became a great gourmet, and had the choicest delicacies served in his famous yellow dining room hung with a collection of his Japanese woodcuts. Six closely-written books of recipes have survived, including tempting dishes such as Truffes à la serviette, entrecôte marchand de vin and the mysterious vert-vert. Making banana ice cream at Christmas was a complicated business involving cranking an ice machine,

Monet's house and garden at Giverny

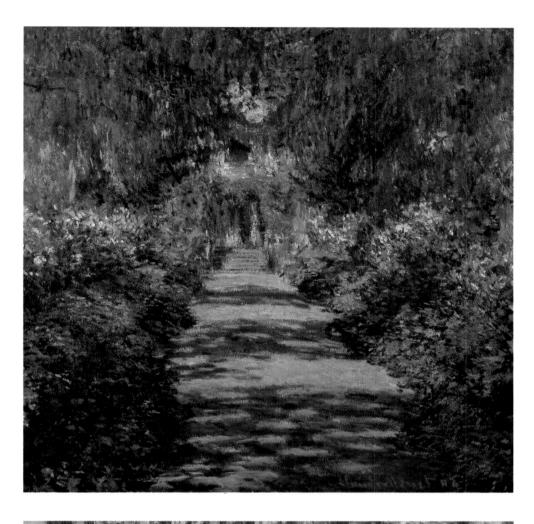

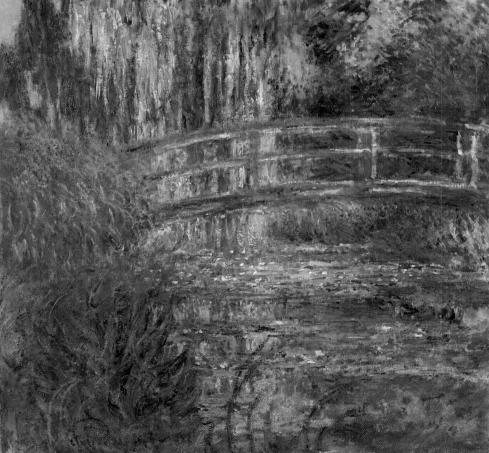

A Path in the Artist's Garden, 1901/02 In the shade of old yew trees, a path with rambling roses trained over it ran down to the south garden gate. The flower beds to right and left were arranged symmetrically.

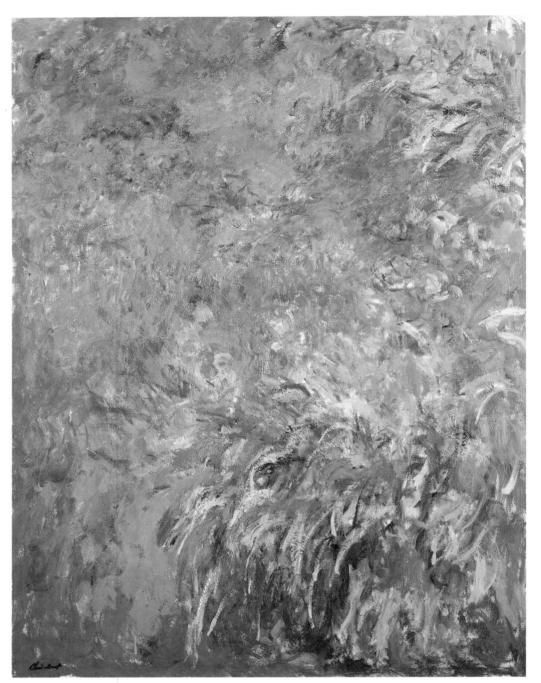

Irises, 1914–17 "Nothing in the whole world is of interest to me but my painting and my flowers." Claude Monet

then a state-of-the-art gadget, for a full half hour. Monet was a collector of recipes, and liked to plan menus and give orders; but he himself never did any of the cooking.

Meals played an important part in Monet's life, and provided the framework for daily life. Early in the morning, often before dawn in summer, he would rise and eat a hearty breakfast of the kind he had grown fond of in Holland. At half past eleven the family and any visitors would lunch; Monet expressly wanted an early lunch in order not to miss any of the afternoon sunlight. Tea would then be taken in the garden, and in the evening a dinner hardly to be described as frugal. The Monets rarely gave dinner parties, though, since the artist liked to turn in early, in order to be up at dawn the next day. The redoubtable Alice saw to it that Monet's work did not suffer under the bustle of the household.

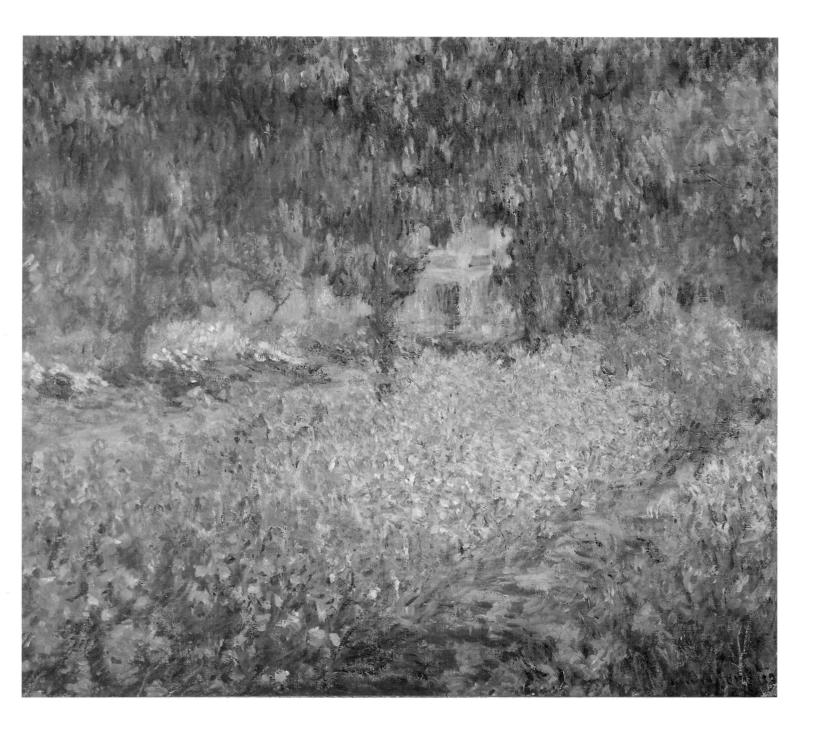

Monet would sit out under his immense white umbrella (cf. p. 71), surrounded by as many as twelve canvases begun at different times of day and in various conditions of weather and light. His stepdaughter Blanche painted at his side from an early date, and after the death of Alice she became his constant companion. Silent and often grumpy, concentrating on his work, Monet would sit at his canvases, periods of great productivity alternating with times of deep depression.

Unlike the villages where Monet had previously lived, Giverny was not on the Seine, but it did have a small river, the Epte, and a number of streams; so Monet's beloved water was flowing all about him. Following his afternoons on the river at Argenteuil and his days facing the sea spray at Etretat, Monet was now in thrall to water in a different form: the pool. In the early 1890s he bought a field below the house, some 7,500 square metres in Irises in the Artist's Garden, 1900

ILLUSTRATION PAGES 80/81:

The waterlily pool was the heart of Monet's life and work. Over the years it was enlarged, and more waterlilies added. A gardener was employed specially for the pool and the waterlilies. Inspired by Japanese woodcuts, Monet had a small Japanese-style wooden bridge built in 1895, overhung with wistaria, and took it as a subject in numerous later paint-ings.

Waterlilies, Water Landscape, Clouds, 1903

size and separated from his property by the railway tracks, and this he converted into a water garden with the aid of a little watercourse that ran through it. He was later to employ a gardener solely to look after the pool and the waterlilies that grew on it, while five more gardeners tended the rest of the grounds. In 1895 he had an arched wooden bridge built, of the kind seen on Japanese woodcuts (cf. pp. 77 and 81). It was his peaceful realm, a place of meditation, hot in the sun, with dragonflies flitting about and frogs plopping into the water if they were disturbed where they rested amid the reeds. The pool – with eelgrass and algae growing in it, irises, reeds and weeping willows along the margins, and on the surface the floating pads of waterlilies glimmering like mother-of-pearl in the sun – was to provide Monet's main subject matter for his last thirty years. Yet again he was palp-

Waterlilies, 1897/98

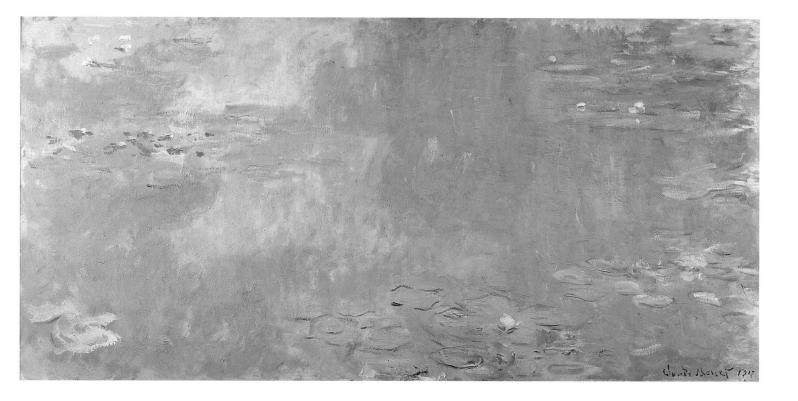

ably concerned to approach his subject closer and closer, till in the huge waterlily pictures of his final years he seemed to be immersed in it. From large-scale landscape composition, Monet moved on via views of the pool and the Japanese bridge to close-up sectional views of the surface of the water. The sky was only a reflection now (p. 82), and no longer appeared at the top of Monet's paintings. His water pictures were landscapes shorn of horizons. However small the section viewed, it might still include the countryside, trees, the sky, or clouds – but of course these were not land-scape paintings in the usual sense; Monet himself called them reflected land-scapes.

Monet frequently insisted that his studio was the open air, but the fact was nevertheless that most of his paintings were completed or reworked in the studio. There were indeed times when he maintained three studios at Giverny, where he would receive visitors and talk about his work. His pool pictures too were not painted exclusively outdoors under his umbrella; but the difference between these and his paintings of the Thames or St. Mark's Square, on which he worked for years in the studio only, was that he could easily refresh his impression of his subject and the light by strolling down to the pool and taking it in anew.

In his waterlily pool paintings, Monet went further than anywhere else in his art towards replacing representation with surface pattern or abstraction. The broad waterlily pads afforded Monet a means of establishing horizontals in his paintings, while the reflections of willows and reeds in particular provided vertical structuring. If these essentially geometrical and balanced patterns are neither monotonous nor lifeless, it is because the decorative lily pads and flowers are irregular in shape, and also, once again, because of Monet's use of colour. With unparalleled skill and subtlety he catches a thousand vibrant nuances of colour, assembling them into a mosaic of light. His dabs and strokes break and disassemble colours to infinity, juxtaposing and

Waterlilies, 1917

"[...] Say, my dream, what shall I do? With a look to embrace the chaste absence of this vast solitude and, as one plucks an enchantingly closed waterlily to remind one of a place, one of the waterlilies that are suddenly there and whose deep whiteness includes the nothingness of an untouched dream, a happiness that will never be, only to go on, holding one's breath in awe of the apparition: to row on, very slowly, in silence, not breaking the spell by dipping the oars, nor with the sound of splashing washing the shimmering semblance of my theft of an ideal flower, visible in the rising bubbles as I flee, before footfalls approaching unexpectedly [...]" Stéphane Mallarmé, Le Nénuphar Blanc

overlaying them. The first layers are extremely thin, almost transparent; yet they gleam through the superimposed, more forceful brushwork and impasto layers. Monet's brushwork underwent constant change. The vibrant, abbreviated strokes and dabs and flickering light of the earliest series (p. 82), transparent yet still with the quality of a tapestry, was steadily replaced by a more fluid style. It was as if Monet's broad, chalky stroke were itself becoming an alga or waterplant. His brushstrokes no longer ran horizontally or vertically, but coiled like mysterious tendrils, and began to dance. It was this freedom and daring in Monet's technique, together with the distance his colours moved from faithful representation, and his audacious use of outsize formats, that made his waterlily paintings so very important for future artists. The abstract expressionists of the 1950s - such as Sam Francis, Jackson Pollock or Mark Rothko - were fascinated by Monet's use of colour. The format of his waterlily decorative panels seems to have anticipated that of Pollock's all-overs. But whereas the abstract expressionists were after an autonomous art of pure form and colour, even the most visionary of Monet's pictures originated in a visual impression of something actually seen - in a word, in Nature.

Immersion in an unending picture seen not only in front of the beholder but all around, as with Monet's waterlily decorative panels, was a particular aim of these painters. Monet himself had been pondering the use of several large-scale waterlily paintings to create a spatial environment ever since the closing years of the 19th century. In accordance with contemporary taste, and surely also with his own, he thought first of decorative panels for a dining room. Later, when Monet had fallen into a profound lethargy following the deaths of his wife Alice and his son Jean, Clemenceau tried to help his friend by proposing he paint a waterlily series for the French nation. A new studio was even built for the project, 24 metres by 12, to accommodate work on a vast scale. Building it was no easy undertaking during the First World

Waterlilies, 1919

Waterlilies, 1916

War, and Monet only managed to obtain the materials and manpower thanks to his friends in high places.

To describe these paintings as decorative may seem now, as it did then, to partake of the dismissive. The adjective was used of Monet's work at a relatively early date, to account for a type of art that was neither narrative, historical nor topographical in character. The late waterlily series are the most radical expression of Monet's decorative art. Pure observations of light and colour, they cannot be taken as symbolic either, even though they may constantly invite us to interpret them symbolically. The fact is that Monet's waterlily decorative paintings are indeed self-referential, but they still represent a given reality, and in so doing cannot be termed abstract.

When Monet's series of haystacks or of Rouen Cathedral were exhibited, friends and critics pointed out time and again that they were conceived as unities, and regretted that trade imperatives would disperse the series throughout the world. For this very reason, Clemenceau had tried in the closing years of the 19th century to secure the cathedral series in its entirety for the French state, only to be thwarted by the official buying commission. In 1918, when Monet proposed giving two large waterlily paintings to the nation to mark the Armistice, Clemenceau and Geffroy succeeded in persuading him that the moment had now come to realise the project of a large-scale ensemble of decorative waterlily paintings.

Monet had long been thinking of presenting the waterlilies in a room in such a way that the illusion of an infinite whole was created and the be-

Waterlily Pond, Evening (diptych), c. 1916–22

"The moment the brush paused, the artist hurried to his flowers or sank into his armchair to think about his work. Eyes closed, his arms hanging casually, he would go in immobile quest of the light that had evaded him, and his perhaps imagined failure to capture it was succeeded by incisive thought about his work plans." Georges Clemenceau

ILLUSTRATION PAGE 87: *Waterlily Pond, Evening* (detail) holder could relax and meditate. He agreed to give the nation a number of paintings on condition that they were hung in a new purpose-built space designed to his own specifications. A suitable location was chosen in the grounds of the Hôtel Biron, where a museum devoted to the sculptor Rodin had recently been established. An architect drew up plans for a pavilion on the edge of the grounds, a circular building by no means gigantic that could hold a dozen panels; but the department of public buildings rejected the proposal, plainly feeling that if Monet had a specially built pavilion for his own paintings it would be bestowing too great an honour on him.

Monet threatened to retract his offer, and prospective buyers began to flock in from Japan and the USA, hoping to acquire the entire series for museums in their own countries. It was owing solely to Clemenceau, who felt the decorative project was "his", that Monet did finally agree to have the waterlily paintings hung in the Louvre's Orangerie. They were installed there in two oval rooms – though not, in the event, till after the artist's death. The Orangerie now attracts large numbers of visitors; but for many years the Monets there were largely ignored, and it was not until the 1950s that the decorative waterlilies were discovered by painters such as Sam Francis. Only in the aftermath of abstract expressionism was the late Monet properly understood and valued. Monet's last years were a time of prolific industry, and far from taking his old age easily, or working quietly on the artistic fruits of a long life, he made greater demands of himself than ever. Fear of producing mediocre work led him to burn and destroy many a picture. He had seen the dealers removing everything of Manet's after his fellow artist's death, and was determined to prevent sketches and unfinished work of dubious value from reaching the market.

From 1908 there were increasing indications that Monet's sight was failing, and in due course an ophthalmologist diagnosed cataracts. After lengthy hesitation, Monet underwent two operations, which restored his sight. In 1919 Renoir, the last of Monet's old fellow-Impressionists, died, leaving the old man alone by the poolside.

Monet was not a religious man; his views were thoroughly positivist. He was a materialist of light. If it had been otherwise, the critics of his final paintings would doubtless long since have been quoting Dante's *Inferno*, claiming the Japanese bridge led to purgatory, and so forth. For it was not Monet's lifelong love of water (in which he wanted his mortal remains dis-

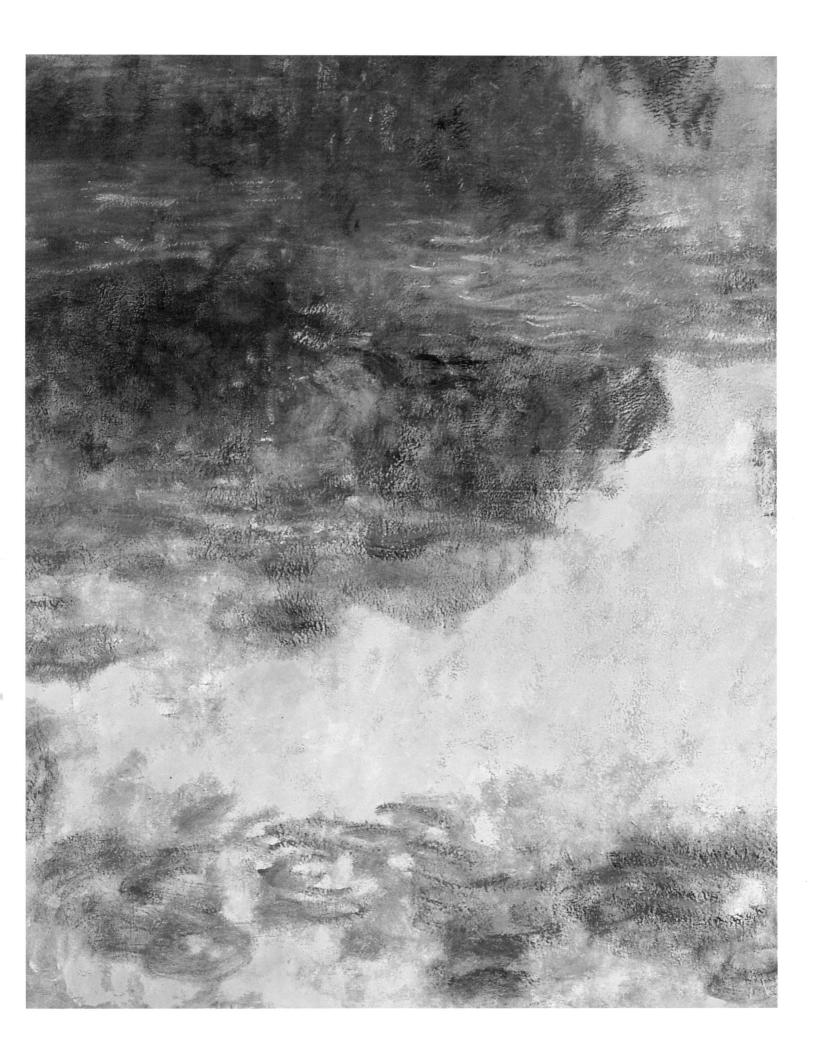

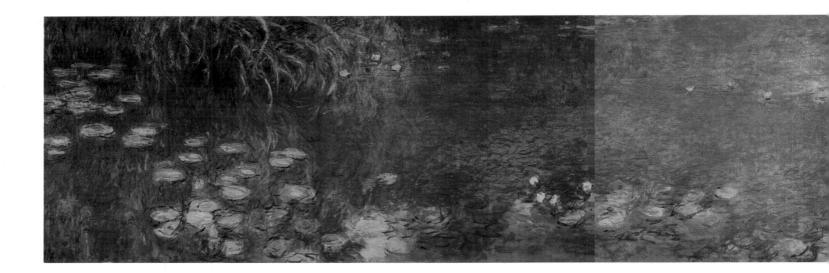

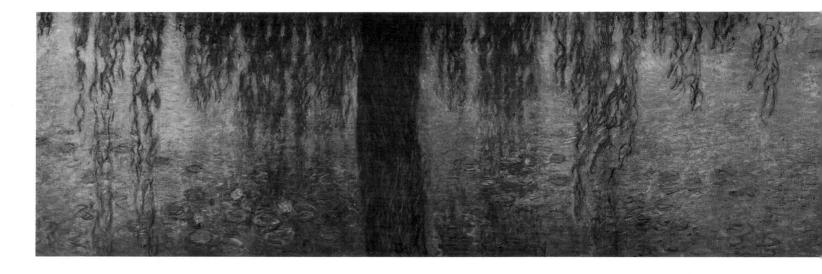

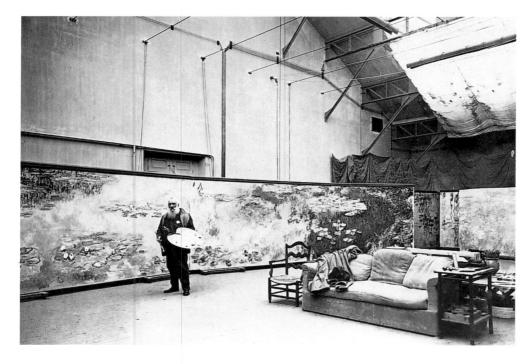

TOP: *Morning* (quadriptych), 1916–26

CENTRE: *Morning with Weeping Willows* (triptych), 1916–26

LEFT:

Monet at work on one of the vast waterlily panels in his third and biggest studio, c. 1923

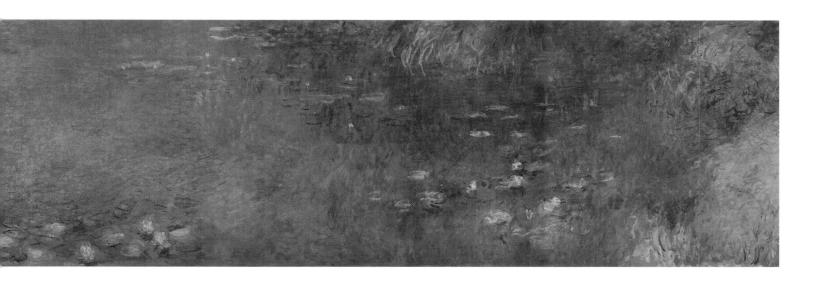

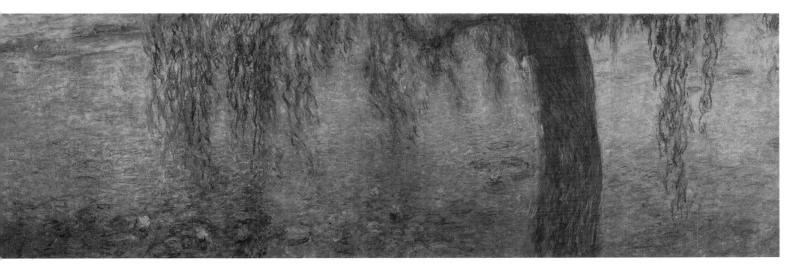

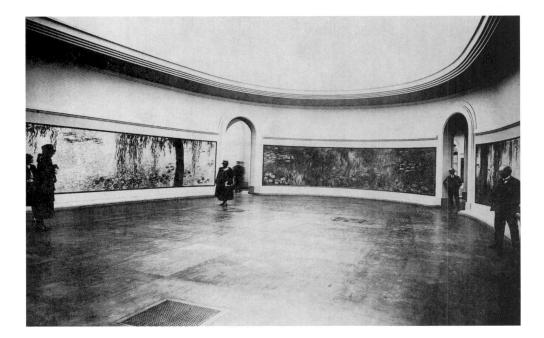

Room II of the Musée de l'Orangerie The artist André Masson called the Orangerie in Paris "the Sistine Chapel of Impressionism". After Monet's death, the waterlily panels he had gifted to the nation were put on public display there. posed of) that dominated his last works, but fire: his pool was in flames. Monet's long life as an artist closed with pictures of powerful energy, pictures that bespoke an unbroken and tenacious vitality in the painter. Monet had helped break the stranglehold that academic eclecticism had had on art in his youth; Monet had taught fellow artists and the general public alike to use their eyes again; Monet was the Prometheus who set modern art ablaze from the sparks of *plein-air* painting; and now it was as if Monet were determined to press Modernism to the ultimate in his own final works. The bright burning strength that was Monet's in all his art and life was extinguished abruptly. On 6 December 1926, he died at the age of eighty-six.

Monet in his third Giverny studio, c. 1923

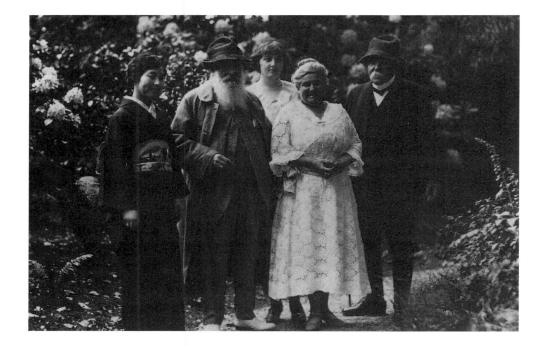

Left to right: Madame Kuroki, Claude Monet, Lily Butler, Blanche Monet and Georges Clemenceau

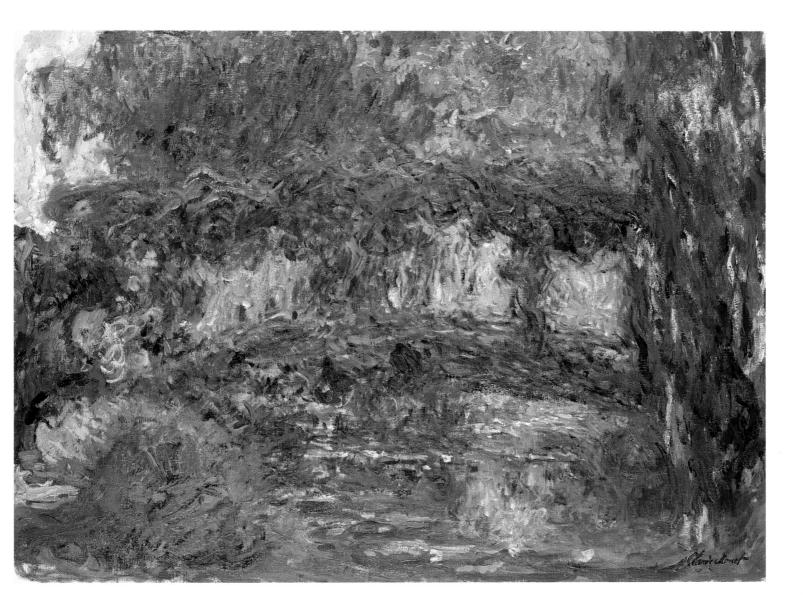

The Japanese Bridge, 1922

Claude Monet 1840–1926: a Chronology

Claude Monet, c. 1875

1840 Claude Oscar Monet is born at 45, Rue Lafitte, Paris, on 14 November, the second son of a shopkeeper.

1845 Business is poor, and the family move to Le Havre, where Monet's father enters his brother-in-law Lecadre's business.

c. 1855 Monet's talent for drawing is apparent in caricatures of teachers and others.

1858 Meets the landscape artist Eugène Boudin (1824–1898) and paints in the open air with him.

1859 Monet goes to Paris to study art. He visits the Salon, and works at the Académie Suisse, where he meets Camille Pissarro (1830–1903).

1860 Monet is called up, and elects to serve with the Chasseurs d'Afrique in Algeria, but is discharged on grounds of ill health the following year.

1862 On holiday in Normandy he meets Johan Barthold Jongkind (1819– 1891). Once Monet's health is restored, his family buys him out of the army, and in November he returns to Paris and enters the studio of artist Charles Gleyre (1806–1874). There he meets Auguste Renoir (1841–1919), Alfred Sisley (1839– 1899) and Frédéric Bazille (1841–1870).

1863 Monet and his new friends paint in the Forest of Fontainebleau. At the end of the year, all four leave Gleyre's studio.

1865 The Salon accepts two Monet marine paintings. He plans an immense *Déjeuner sur l'herbe* for the next Salon and starts work on it in the Forest of Fontainebleau immediately.

1866 Lady in a Green Dress is exhibited at the Salon and well received. Monet spends summer and autumn with his family at Sainte-Adresse and Hon-fleur.

1867 Again he summers with his parents, while Camille gives birth to their first son Jean in Paris. Back in Paris, Bazille shares his studio with Monet and buys *Women in the Garden*, which the Salon has turned down, by instalments.

1868 Works at Etretat and Fécamp. Gaudibert, a ship owner, helps Monet through financial difficulties from 1864 on, and now gives him commissions and redeems pawned pictures.

1870 Again rejected by the Salon. 26 June: marries Camille Doncieux. On the outbreak of the Franco-Prussian War a month later, Monet moves to London, where the news of Bazille's death reaches him in November. In London he meets art dealer Paul Durand-Ruel.

1871 17 January: Monet's father dies, leaving a modest legacy. In the autumn, Monet returns to France via Holland, and rents a house and garden at Argenteuil.

1872 Durand-Ruel buys a large selection of paintings. Monet creates his studio boat and paints the banks of the Seine. At Le Havre he paints *Impression, Sun Rising*. Second visit to Holland.

1873 Works quietly at Argenteuil, where he meets Gustave Caillebotte

(1848–1894). The *Société Anonyme Co-opérative d'Artistes-Peintres, -Sculpteurs, -Graveurs, etc.* is founded to put on group shows. The members include the core Impressionists.

1874 The first group exhibition is held in the rooms of Nadar, the photographer, in Boulevard des Capucines, Paris. Leroy takes the title of *Impression, Sun Rising* as a platform in an article deriding artists who merely presented impressions rather than finished artworks. The show is a fiasco, and the *Société Anonyme* is dissolved at the end of the year.

1875 In financial difficulty again, Monet moves to a smaller house.

1876 At the second Impressionist show in Durand-Ruel's gallery, Monet exhibits 18 paintings. He meets departmentstore director Ernest Hoschedé, who commissions panels for a room in his château, Rottenbourg, near Montgeron. This year and the next, Monet paints the Gare Saint-Lazare.

1878 Birth of the Monets' second son, Michel, in Paris. In the summer, the family move to a small house at Vétheuil, where Alice Hoschedé and her six children joins them. The money problems continue.

1879 Caillebotte funds the fourth group exhibition. Monet paints at Vétheuil and Lavacourt. 5 September: Camille dies at the age of 32.

1881 Durand-Ruel buys more Monets and assists Monet in his travels. In December Monet, Alice Hoschedé and their children move to Poissy.

1883 Monet's solo exhibition at Durand-Ruel's is well received but does not result in many sales. Durand-Ruel commissions decorative work for his Paris home. Monet rents the house at Giverny, and in December goes to the south of France with Renoir.

1884 January to April: painting on the Riviera.

1886 Revisits Holland. In the autumn he paints at Etretat and in Brittany, where

he meets his biographer-to-be, Gustave Geffroy.

1887 Durand-Ruel opens a New York gallery and exhibits Monet's works there. A Monet show at Georges Petit's in Paris, where he already exhibited in 1885, is a great success.

1888 From January to April he works on the Côte d'Azur and in summer revisits London. Back in France, he refuses the Cross of the Legion of Honour. Begins the *Haystacks* series.

1889 Georges Petit mounts a highly successful joint show of Monet and Auguste Rodin (1840–1917). Monet organizes a collection to buy Manet's *Olympia* from his widow, for the Louvre.

1890 Works on the *Haystacks* and begins the *Poplars* series. Buys the Giverny house where he has been living since 1883.

1891 The *Haystacks* exhibition at Durand-Ruel's is a great success. December: painting in London.

1892 Spring: works on the *Rouen Cathedral* series. Ernest Hoschedé having died the previous year, Monet and Alice Hoschedé marry in July.

1895 Monet visits his stepson in Norway. In March, Durand-Ruel exhibits the *Rouen Cathedral* series.

1896 Working in Normandy again, at Varengeville, Dieppe and Pourville. Begins his series *Morning by the Seine*.

1897 January to March: at Pourville. Builds a second studio at Giverny. In the summer, his son marries his stepsister Blanche Hoschedé. The second Venice Biennale includes 20 Monets.

1899 Monet begins his waterlilies series in the water gardens at Giverny. In the autumn he revisits London and paints views of the Thames again.

1900 Several visits to London. In the spring he works at Giverny, in the summer at Vétheuil.

1903 Studio work on the London pictures (till 1905). Death of Pissarro on 12 November.

1904 In the autumn he drives to Madrid with Alice in a motor car, to study the Spanish masters such as Diego Velázquez.

1906 Monet continues work on his waterlilies series but is dissatisfied and repeatedly postpones the exhibition due at

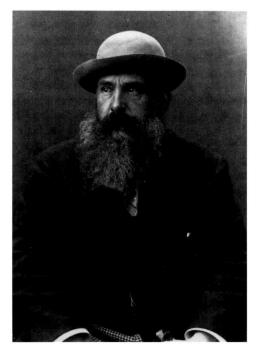

Claude Monet, 1901 Photograph by Gaspar Félix Nadar

Durand-Ruel's. Death of Cézanne on 22 October.

1908 First signs that his sight is failing. September to December in Venice with Alice.

1911 Alice Monet dies on 19 May.

1912 The Bernheim-Jeune gallery mounts a highly successful show of Monet's Venice work. His eyesight deteriorates, and an ophthalmologist diagnoses cataracts.

1914 Clemenceau and other friends suggest Monet give a waterlilies series to the nation. Following his son Jean's death, Blanche, Jean's widow, takes over the running of the Giverny household. 3 August: France declares war.

1915 Monet has a third studio built in order to work on the decorative water-lilies project.

1918 On the occasion of the Armistice

(11 November), Monet gives eight waterlily pictures to the nation.

1919 Death of Auguste Renoir on 17 December, the last of Monet's old Paris friends.

1921 Major retrospective at Durand-Ruel's. Depressed and in despair at his failing sight, Monet plans to withdraw his gift.

1922 At the urging of Clemenceau, who has promoted the project from the outset, Monet signs the deed of gift.

1923 Monet undergoes two operations, which restore his sight, and returns to painting. Frequently depressed and downhearted, he continues work on the great decorative waterlilies.

1926 6 December: Claude Monet dies at Giverny.

List of Plates

The numbered references to Wildenstein are to Daniel Wildenstein: *Monet, biographie et catalogue raisonée*, I-IV, Lausanne and Paris, 1974–85.

Self-Portrait in a Beret, 1886 Autoportrait de Claude Monet, coiffé d'un béret Oil on canvas, 56 x 46 cm. Wildenstein 1078 Private collection Festivities in the Rue Saint-Denis, 30 June 1878, 1878 La Rue Saint-Denis, fête du 30 juin 1878 Oil on canvas, 76 x 52 cm. Wildenstein 470 Rouen, Musée des Beaux-Arts Studio Still Life, 1861 Coin d'atelier Oil on canvas, 182 x 127 cm. Wildenstein 6 Paris, Musée d'Orsay The Notary Léon Marchon, c. 1855/56 Léon Marchon Charcoal with white chalk highlighting, on bluish grey paper, 61.2 x 45.2 cm Chicago (IL), The Art Institute of Chicago, Gift of Carter H. Harrison, 1933.888 8 top The Road to Saint-Siméon's Farm near Honfleur, 1864 La route de la ferme St. Siméon Oil on canvas, 82 x 46 cm. Wildenstein 29 Tokyo, The National Museum of Western Art, The Matsukata Collection 8 bottom Eugène Boudin: The Beach at Trouville, 1864 La Plage de Trouville Oil on panel, 26 x 48 cm Paris, Musée d'Orsay Cape La Hève at Ebb Tide, 1865 La Pointe de la Hève à marée basse Oil on canvas, 90.2 x 150.2 cm. Wildenstein 52 Fort Worth (TX), Kimbell Art Museum 10 top left Avenue at Chailly, 1865 Le Pavé de Chailly Oil on canvas, 43 x 59 cm. Wildenstein 56 Paris, Musée d'Orsay 10 top right Frédéric Bazille: Improvised Treatment, 1865 L'Ambulance improvisée Oil on canvas, 47 x 65 cm Paris, Musée d'Orsay 10 bottom Charles Gleyre Daphnis and Chloé Returning from the Mountains, 1862 Daphnis et Chloé revenant de la montagne Oil on canvas, 80 x 62.2 cm Private collection 11 Le déjeuner sur l'herbe (study), 1865 Oil on canvas, 130 x 181 cm. Wildenstein 62 Moscow, Pushkin Museum 12 top Claude Monet at his Giverny home with the Duc de Trévise, 1920 Photograph 12 bottom Edouard Manet: Le déjeuner sur l'herbe, 1863 Oil on canvas, 208 x 264 cm Paris, Musée d'Orsay 13 left Le déjeuner sur l'herbe (left section), 1865 Oil on canvas, 418 x 150 cm. Wildenstein 63a Paris, Musée d'Orsay 13 right Le déjeuner sur l'herbe (centre section), 1865 Oil on canvas, 248 x 217 cm. Wildenstein 63b Paris, Musée d'Orsay 14 Luncheon, 1868 Le déjeuner

Frankfurt am Main, Städtische Galerie im Städelschen Kunstinstitut 15 Camille, or, Lady in a Green Dress, 1866 Camille ou Femme à la robe verte Oil on canvas, 231 x 151 cm. Wildenstein 65 Bremen, Kunsthalle Bremen 16 Women in the Garden, 1866 Femmes au jardin Oil on canvas, 255 x 205 cm. Wildenstein 67 Paris, Musée d'Orsay 17 "Petit Courier des Dames." illustration from a fashion magazine, 1864 18 Church of Saint-Germain-l'Auxerrois, 1867 Oil on canvas, 79 x 98 cm. Wildenstein 84 Berlin, Staatliche Museen zu Berlin - Preußischer Kulturbesitz, Nationalgalerie 19 The Garden of the Infanta, 1867 Le jardin de l'infante Oil on canvas, 91 x 62 cm. Wildenstein 85 Oberlin (OH), Allen Memorial Art Museum, Oberlin College; R. T. Miller, Jr. Fund, 1948 20 top Garden at Sainte-Adresse, c. 1866 Jardin en fleurs Oil on canvas, 65 x 54 cm. Wildenstein 69 Paris, Musée d'Orsay 20 bottom Katsushika Hokusai: The Sazai Pavilion at the Temple of the Five Hundred Rakan, from: Thirty-six Views of Mount Fuji, 1829-33 Woodcut print, 23.9 x 34.3 cm Giverny, Académie des Beaux-Arts, Fondation Claude Monet 21 Terrace at Sainte-Adresse, 1867 Terrasse à Sainte-Adresse Oil on canvas, 98.1 x 129.9 cm. Wildenstein 95 New York (NY), The Metropolitan Museum of Art, Purchased with special contribution and purchase funds given or bequeathed by friends of the Museum, 1967. (67.241) 22 The River, Bennecourt, 1868 Au bord de l'eau, Bennecourt Oil on canvas, 81.5 x 100.7 cm. Wildenstein 110 Chicago (IL), The Art Institute of Chicago, Mr. and Mrs. Potter Palmer Collection, 1922.427 23 Stormy Sea at Etretat, c. 1873 Grosse mer à Etretat Oil on canvas, 66 x 131 cm. Wildenstein 127 Paris, Musée d'Orsay 24 The Walk. Lady with a Parasol, 1875 La Promenade. La femme à l'ombrelle Oil on canvas, 100 x 81 cm. Wildenstein 381 Washington (DC), National Gallery of Art, Mr. and Mrs. Paul Mellon Collection 25 Anthony Morlon: La Genouillère (detail), 1880-90 Lithograph Paris, Bibliothèque Nationale 26 Regatta at Argenteuil, 1872 Régates à Argenteuil Oil on canvas, 48 x 75 cm. Wildenstein 233 Paris, Musée d'Orsay 27 Hôtel des Roches Noires, Trouville, 1870 Oil on canvas, 80 x 55 cm. Wildenstein 155 Paris, Musée d'Orsay 28 top Miranda: La Grenouillère, from: L'Illustration, August 1873 28 bottom Auguste Renoir: La Grenouillère, 1869 Oil on canvas, 66 x 81 cm Stockholm, National Museum 29 La Grenouillère, 1869 Oil on canvas, 74.5 x 99.7 cm. Wildenstein 134

Oil on canvas, 230 x 150 cm. Wildenstein 132

New York (NY), The Metropolitan Museum of Art, H.O. Havemeyer Collection, Bequest of Mrs. H.O. Havemeyer, 1929. (29.100.112) 30 top The Port of Zaandam, 1871 Le port de Zaandam Oil on canvas, 47 x 74 cm. Wildenstein 188 Private collection 30 bottom J.M.W. Turner: Yacht Approaching the Coast, 1838–40 Oil on canvas, 102 x 142 cm London, The Tate Gallery 31 Impression, Sun Rising, 1873 Impression, soleil levant Oil on canvas, 48 x 63 cm. Wildenstein 263 Paris, Musée Marmottan **32 top** Nadar's house at 35 Boulevard des Capucines, where the first Impressionist exhibition was held in the photographer's studios in 1874. Photograph 32 bottom Detail from illustration on p.33 33 Boulevard des Capucines, 1873 Oil on canvas, 79.4 x 60.6 cm. Wildenstein 293 Kansas City (MO), The Nelson-Atkins Museum of Art, (Purchase: The Kenneth A. and Helen F. Spencer Foundation Acquisition Fund) F 72-35 34 Detail from illustration on p.35 35 The Railway Bridge at Argenteuil, 1873 Le pont du chemin de fer à Argenteuil Oil on canvas, 58.2 x 97.2 cm. Wildenstein 279 Private collection 36 top The Luncheon, 1873 Le déjeuner (panneau décoratif) Oil on canvas, 160 x 201 cm. Wildenstein 285 Paris, Musée d'Orsay 36 bottom Auguste Renoir: Monet Painting in his Garden at Argenteuil, 1873 Monet peignant dans son jardin à Argenteuil Oil on canvas, 46.7 x 59.7 cm Hartford (CT), Wadsworth Atheneum. Bequest of Anne Parrish Titzell 37 Jean Monet in the Artist's Home, 1875 Un coin d'appartement Oil on canvas, 80 x 60 cm. Wildenstein 365 Paris, Musée d'Orsay 38 left Edouard Manet: Claude Monet and his Wife in his Studio Boat, 1874 Claude Monet et sa femme dans son studio flottant Oil on canvas, 82.5 x 100.5 cm Munich, Neue Pinakothek 38 right The Studio Boat, 1874 Le Bateau-atelier Oil on canvas, 50 x 64 cm. Wildenstein 323 Otterlo, Kröller-Müller Stichting 39 Poppy Field at Argenteuil, 1873 Les coquelicots à Argenteuil Oil on canvas, 50 x 65 cm. Wildenstein 274 Paris, Musée d'Orsay 40 top The Bridge at Argenteuil, 1874 Le pont d'Argenteuil Oil on canvas, 60 x 81.3 cm. Wildenstein 313 Munich, Neue Pinakothek 40 bottom The Railway Bridge at Argenteuil, 1873 Le pont du chemin de fer, Argenteuil Oil on canvas, 54 x 71 cm. Wildenstein 319 Paris, Musée d'Orsay 41 top Gare Saint-Lazare. Arrival of a Train, 1877 La Gare Saint-Lazare, arrivée d'un train Oil on canvas, 83.1 x 101.5 cm. Wildenstein 439 Cambridge (MA), Courtesy of The Fogg Art Museum, Harvard University Art Museums, Bequest - Collection of Maurice Wertheim, Class of 1906

41 bottom La Gare Saint-Lazare, 1877 Drawing Paris, Musée Marmottan 42 top Unloading Coal at Argenteuil, 1875 Les déchargeurs de charbon, Argenteuil 1872 Oil on canvas, 55 x 66 cm. Wildenstein 364 Paris, Document Archives Durand-Ruel 42 bottom Utagawa Hiroshige: The Kujukuri Coast in Kazusa Province, from: Famous Places in over Sixty Provinces, 1853–56 Woodcut print, 66.6 x 22.4 cm Giverny, Académie des Beaux-Arts, Fondation Claude Monet 43 La Japonaise, 1875 Oil on canvas, 231.6 x 142.3 cm. Wildenstein 387 Boston (MA), Courtesy, Museum of Fine Arts, 1951 Purchase Fund 44 The Church at Vétheuil, Winter, 1879 *Eglise de Vétheuil, neige* Oil on canvas, 65.3 x 50.5 cm. Wildenstein 505 Paris, Musée d'Orsay 45 Portrait of Camille Monet (?), 1866/67 Portrait de Camille Monet Red chalk drawing Private collection 46 Camille Monet on her Deathbed, 1879 Camille Monet sur son lit de mort Oil on canvas, 90 x 68 cm. Wildenstein 543 Paris, Musée d'Orsay 47 top Ice Floes at Vétheuil, 1880 La débâcle près de Vétheuil Oil on canvas, 65 x 93 cm. Wildenstein 572 Paris, Musée d'Orsay 47 bottom Vétheuil in the Mist, 1879 Vétheuil dans le brouillard Oil on canvas, 60 x 71 cm. Wildenstein 518 Paris, Musée Marmottan 48 top Paul Durand-Ruel Photograph Paris, Document Archives Durand-Ruel 48 bottom The large salon at Paul Durand-Ruel's home at 35 rue de Rome, Paris Paris, Document Archives Durand-Ruel 49 Still Life with Pears and Grapes, 1880 Poires et raisin Oil on canvas, 65 x 81 cm. Wildenstein 631 Hamburg, Hamburger Kunsthalle 50 top The Customs Post at Varengeville, 1882 Cabane du Douanier à Varengeville Oil on canvas, 60 x 78 cm. Wildenstein 732 Rotterdam, Museum Boymans-van Beuningen 50 bottom The Customs Post at Varengeville, 1882 Cabane du Douanier à Varengeville Oil on canvas, 60 x 81 cm. Wildenstein 743 Philadelphia (PA), Philadelphia Museum of Art, William L. Elkins Collection 51 A Walk on the Cliffs at Pourville, 1882 La promenade sur la falaise, Pourville Oil on canvas, 66.5 x 82.3 cm. Wildenstein 758 Chicago (IL), The Art Institute of Chicago, Mr. and Mrs. Lewis Larned Coburn Memorial Collection, 1933.443 52 The "Pyramids" at Port-Coton, 1886 Les »Pyramides« de Port-Coton Oil on canvas, 65 x 81 cm. Wildenstein 1084 Moscow, Pushkin Museum 53 top The Manneporte at Etretat, 1886 La Manneporte près d'Etretat Oil on canvas, 81.3 x 65.4 cm. Wildenstein 1052 New York (NY), The Metropolitan Museum of Art, Bequest of Lizzie P. Bliss, 1931. (31.67.11)

53 bottom The cliffs near Etretat Photograph 54 Poplars on the Banks of the Epte, 1891 Peupliers au bord de l'Epte, vue du marais Oil on canvas, 88 x 93 cm. Wildenstein 1312 Private collection 55 top Poplars, Three Pink Trees in Autumn, 1891 Les peupliers, trois arbres roses, automne Oil on canvas, 93 x 74.1 cm. Wildenstein 1307 Philadelphia (PA), Philadelphia Museum of Art, Gift of Chester Dale 55 bottom Three Poplars in Summer, 1891 *Les trois arbres, été* Oil on canvas, 92 x 73 cm. Wildenstein 1305 Tokyo, The National Museum of Western Art, The Matsukata Collection 56 left Open Air Study, Woman Facing Right, 1886 Essai de figure en plein air, vers la droite Oil on canvas, 131 x 88 cm. Wildenstein 1076 Paris, Musée d'Orsay 56 right Open Air Study, Woman Facing Left, 1886 Essai de figure en plein air, vers la gauche Oil on canvas, 131 x 88 cm. Wildenstein 1077 Paris, Musée d'Orsay **57 top** Rouen Cathedral, c. 1900 Photograph 57 bottom Haystacks, c. 1888/89 Meules Drawing Paris, Musée Marmottan 58 top Haystack, Snow, Overcast Sky, 1891 Meule, effet de neige, temps couvert Oil on canvas, 66 x 93 cm. Wildenstein 1281 Chicago (IL), The Art Institute of Chicago, Mr. and Mrs. Martin A. Ryerson Collection, 1933.1155 58 bottom Haystack in the Snow, Morning, 1891 Meule, effet de neige, le matin Oil on canvas, 65.4 x 92.3 cm. Wildenstein 1280 Boston (MA), Courtesy, Museum of Fine Arts, Gift of Misses Aimee and Rosamond Lamb in Memory of Mr. and Mrs. Horatio A. Lamb 59 top Haystack in Sunshine, 1891 Meule au soleil Oil on canvas, 60 x 100 cm. Wildenstein 1288 Zurich, Kunsthaus Zürich 59 bottom Haystacks in a Thaw at Sunset, 1891 Meules, dégel, soleil couchant Oil on canvas, 64.9 x 92.3 cm. Wildenstein 1284 Chicago (IL), The Art Institute of Chicago, Gift of Mr. and Mrs. Daniel C. Searle, 1983.166 60 top left Rouen Cathedral in the Morning. The main entrance and the Saint-Romain Tower, 1894 La Cathédrale de Rouen. Le portail et la tour Saint-Romain à l'aube Oil on canvas, 106 x 74 cm. Wildenstein 1348 Boston (MA), Courtesy, Museum of Fine Arts, The Tompkins Collection 5831C 60 top centre Rouen Cathedral. The main entrance in morning sun. Harmony in blue, 1894 La Cathédrale de Rouen. Le portail, soleil matinal. Harmonie bleue Oil on canvas, 91 x 63 cm. Wildenstein 1355 Paris, Musée d'Orsay 60 top right Rouen Cathedral. The main entrance and the Saint-Romain Tower in the morning. Harmony in white, 1894 La Cathédrale de Rouen. Le portail et la tour Saint-Romain, effet du matin. Harmonie blanche Oil on canvas, 106 x 73 cm. Wildenstein 1346 Paris, Musée d'Orsay 60 bottom left Rouen Cathedral. The main entrance and the Saint-Romain Tower in bright sunlight. Harmony in blue and gold, 1894

La Cathédrale de Rouen. Le portail et la tour Saint-Romain plein soleil. Harmonie bleue et or Oil on canvas, 107 x 73 cm. Wildenstein 1360 Paris, Musée d'Orsay 60 bottom centre Rouen Cathedral. The main entrance and Saint-Romain Tower on a dull day. Harmony in grey, 1894 La Cathédrale de Rouen. Le portail, temps gris. Harmonie grise Oil on canvas, 100 x 65 cm. Wildenstein 1321 Paris, Musée d'Orsay 60 bottom right Rouen Cathedral. The main entrance. Harmony in brown, 1894 La Cathédrale de Rouen. Le portail vu de face. Harmonie brune Oil on canvas, 107 x 73 cm. Wildenstein 1319 Paris, Musée d'Orsay 61 see p. 60, top left 62 top Villas at Bordighera, 1884 Les Villas à Bordighera Oil on canvas, 115 x 130 cm. Wildenstein 857 Santa Barbara (CA), The Santa Barbara Museum of Art 62 bottom Palm Trees at Bordighera, 1884 Palmiers à Bordighera Oil on canvas, 64.8 x 81.3 cm. Wildenstein 877 New York (NY), The Metropolitan Museum of Art, Bequest of Miss Adelaide Milton de Groot (1876-1967), 1967. (67.187.87) 63 Bordighera, 1884 Oil on canvas, 64.8 x 81.3 cm. Wildenstein 854 Chicago (IL), The Art Institute of Chicago, Mr. and Mrs. Potter Palmer Collection, 1922.426 64 View of Menton from Cap Martin, 1884 Menton vu du Cap Martin Oil on canvas, 67.2 x 81.6 cm. Wildenstein 897 Boston (MA), Courtesy, Museum of Fine Arts, Julia Cheney Edwards Collection **65 top** Antibes in Afternoon Light, 1888 Antibes, effet d'après-midi Oil on canvas, 65.5 x 81 cm. Wildenstein 1158 Boston (MA), Courtesy, Museum of Fine Arts, Anonymous gift 65 bottom View of the Esterel Mountains, 1888 Montagnes de l'Esterel Oil on canvas, 65 x 92 cm. Wildenstein 1192 London, Courtauld Institute Galleries 66 top Mount Kolsaas with Pink Reflections, 1895 Le Mont Kolsaas, reflets roses Oil on canvas, 65 x 100cm. Wildenstein 1415 Paris, Musée d'Orsay 66 bottom Monet and Theodore Butler in the car Photograph. Collection Jean-Marie Toulgouat 67 The Houses of Parliament, 1899-1901 Le Parlement, trouée de soleil dans le brouillard Oil on canvas, 81 x 92 cm. Wildenstein 1610 Paris, Musée d'Orsay 68 Evening in Venice, 1908 *Crépuscule à Venise* Oil on canvas, 73 x 92 cm. Wildenstein 1769 Tokyo, Bridgestone Museum of Art, Ishibashi Foundation 69 top Palazzo Contarini, 1908 Le Palais Contarini Oil on canvas, 92 x 81 cm. Wildenstein 1767 St. Gallen, Kunstmuseum St. Gallen, purchased by the Ernst Schürpf Stiftung in 1950 69 bottom Monet and his wife Alice in St. Mark's Square, Venice, 1908 Photograph Paris, © Collection Philippe Piguet 70 The Japanese Bridge, 1899 Le Bassin aux Nymphéas Oil on canvas, 92.7 x 73.7 cm. Wildenstein 1518 New York (NY), The Metropolitan Museum of Art,

Bequest of Mrs. H.O. Havemeyer, 1929. H.O. Havemeyer Collection (29.100113) 71 Monet painting the waterlily pond with Blanche Hoschedé-Monet and Nitia Salerou, 1915 Photograph Paris, © Collection Philippe Piguet 72 Spring, 1886 Le Printemps Oil on canvas, 65 x 81 cm. Wildenstein 1066 Cambridge, Fitzwilliam Museum Poppy Field in a Valley near Giverny, 1885 Champ de coquelicots, environs de Giverny Oil on canvas, 65.2 x 81.2 cm. Wildenstein 1000 Boston (MA), Courtesy, Museum of Fine Arts, Julia Cheney Edwards Collection 74 The Barque, 1887 Le baraue Oil on canvas, 146 x 133 cm. Wildenstein 1154 Paris, Musée Marmottan 75 top Girls in a Boat, 1887 Jeunes filles en barque Oil on canvas, 145 x 132 cm. Wildenstein 1152 Tokyo, The National Museum of Western Art, The Matsukata Collection 75 bottom Boat on the River Epte, 1890 En canot sur l'Epte Oil on canvas, 133 x 145 cm Wildenstein 1250 São Paulo, Museu de Arte de São Paulo 76 top Monet in his garden at Giverny, c. 1917 Colour photograph by Etienne Clémentel 76 centre Monet's house and garden at Giverny, c. 1917 Colour photograph by Etienne Clémentel 76 bottom Monet's house and garden at Giverny Photograph Giverny, Musée Claude Monet 77 top A Path in the Artist's Garden, 1901/02 *Une allée du jardin de Monet, Giverny* Oil on canvas, 89 x 92 cm. Wildenstein 1650 Vienna, Österreichische Galerie 77 bottom The Japanese Bridge, 1900 Le bassin aux nymphéas Oil on canvas, 89.2 x 92.8 cm. Wildenstein 1630 Boston (MA), Courtesy, Museum of Fine Arts, Given in Memory of Governor Alvan T. Fuller by the Fuller Foundation 78 Irises, 1914-17 Iris Oil on canvas, 199.4 x 150.5 cm. Wildenstein 1832 Richmond (VA), Virginia Museum of Fine Arts, The Adolph D. and Wilkins C. Williams Fund 79 Irises in the Artist's Garden, 1900 Le jardin de Monet, les iris Oil on canvas, 81 x 92 cm. Wildenstein 1624 Paris, Musée d'Orsay 80/81 The waterlily pool Photograph 82 top Waterlilies, Water Landscape, Clouds, 1903 Nymphéas, paysage d'eau, les nuages Oil on canvas, 74 x 106.5 cm. Wildenstein 1656 Private collection 82 bottom Waterlilies, 1897-98 Nymphéas Oil on canvas, 66 x 104 cm. Wildenstein 1501 Los Angeles (CA), Los Angeles County Museum of Art, Bequest of Mrs. Fred Hathaway Bixby 83 Waterlilies, 1917 Les nymphéas à Giverny Oil on canvas, 100 x 200 cm. Wildenstein 1886 Nantes, Musée des Beaux-Arts, Don de la Société des

Waterlilies, 1919 Nymphéas Oil on canvas, 100 x 200 cm Private collection 85 Waterlilies, 1916 Nymphéas Oil on canvas, 200 x 200 cm. Wildenstein 1800 Tokyo, The National Museum of Western Art, The Matsukata Collection 86 Waterlily Pond, Evening (diptych), c. 1916-22 Le bassin aux nymphéas, le soir (diptychon) Oil on canvas, 200 x 600 cm. Wildenstein 1964/65 Zurich, Kunsthaus Zürich 87 Detail from illustration on p.86 88/89 top Morning (quadriptych), 1916-26 Le bassin aux nymphéas sans saules: Matin (quadriptychon) Oil on canvas, 200 x 200, 200 x 425, 200 x 425, 200 x 200 cm. Wildenstein IV p. 328, 4a-d Paris, Musée de l'Orangerie 88/89 centre Morning with Weeping Willow (triptych), 1916-26 Le bassin aux nymphéas avec saules: Le matin clair aux saules triptychon) Oil on canvas, 200 x 425 cm each Wildenstein IV S. 329, 4a-c Paris, Musée de l'Orangerie 88 bottom Monet in the Atelier des Grandes Décorations, c. 1923 Photograph Paris, rights reserved - Document Archives Durand-Ruel 89 bottom Room II of the Musée de l'Orangerie, with the painting Reflets d'arbres on the rear wall and willow compositions to right and left. Photograph Paris, Roger Viollet 90 top Monet in his third Giverny studio, c. 1923 Photograph Paris, rights reserved - Document Archives Durand-Ruel 90 bottom A walk at Giverny. From left to right: Madame Kuroki, Monet, Lily Butler, Blanche Monet and Georges Clemenceau Photograph 91 The Japanese Bridge, 1922 Le pont japonais Oil on canvas, 89 x 116cm Minneapolis (MN), The Minneapolis Institute of Arts, Bequest of Putnam Dana McMillan

The publishers wish to thank the museums, collectors and photographers who helped make this book possible. In addition to the persons and institutions named in the credits, thanks are due to: Acquavella Galleries, New York (54); Photograph © 1993, The Art Institute of Chicago, All Rights Reserved (7, 22, 51, 58 bottom, 63); Artothek, Peissenberg (38 bottom left, 40 top); Michael Bodycomb (9); The Bridgeman Art Library (20 left, 30 top, 30 bottom); Christie's Images (35); Ebbe Carlsson (72); © Harlingue-Viollet (80/81); Photo Luiz Hossaka (75 bottom); © P. Jean (83); © 1993 Museum Associates, Los Angeles County Museum of Art. All Rights Reserved (82 bottom); Photo Henri Manuel (88 bottom); © Photo R.M.N. (6, 8 bottom, 10 top left, 10 top right, 12 bottom, 13 left, 13 right, 16, 23, 26, 27, 36 top, 37, 39, 40 bottom, 44, 46, 47 top, 56 left, 56 right, 60 top centre, 60 top right, 60 bottom left, 60 bottom centre, 60 bottom right, 66 top, 67, 77 top, 79, 88/89 top, 88/89 centre); © Roger-Viollet (12 top, 76 bottom); Foto Scala, Florence (52); Elke Walford (49); Archiv Walther, Alling (90 bottom, 92, 93).

Amis du Musée, 1938